# GARAGE

GA

# RAGE

Olivia Erlanger and Luis Ortega Govela

The MIT Press   •   Cambridge, Massachusetts   •   London, England

This book was set in Minion and Neue Haus Grotesk by The MIT Press. Printed and bound in the United States of America.

Library of Congress Cataloging-in-Publication Data

Names: Erlanger, Olivia, author. | Ortega Govela, Luis, author.
Title: Garage / Olivia Erlanger and Luis Ortega Govela.
Description: Cambridge, MA : The MIT Press, 2018.
Identifiers: LCCN 2017055647 | ISBN 9780262038348 (hardcover : alk. paper)
Subjects: LCSH: Garages--Social aspects--United States. | Domestic
    space--United States--History--20th century. | Suburban life--United
    States--History--20th century. | Architecture and society--United
    States--History--20th century.
Classification: LCC NA8348 .E75 2018 | DDC 728/.980973--dc23 LC record available at
https://lccn.loc.gov/2017055647

10  9  8  7  6  5  4  3  2  1

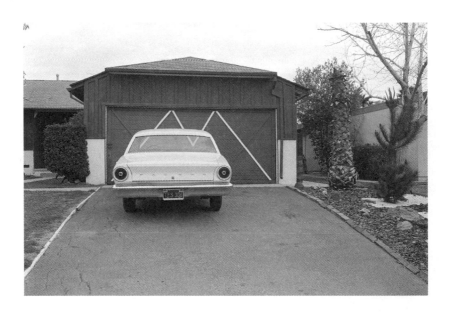

The images of garage doors that appear at the beginning of each chapter
are part of John Divola's first photographic series, San Fernando Valley.
The photos were taken during the early 1970s in Van Nuys, California,
where the photographer grew up. The neighborhood was made up of small,
nearly identical tract homes, and it was in the surface of the pre-automatic
garage doors that the personalities of the owners came through.

# CONTENTS

# INTRODUCTION

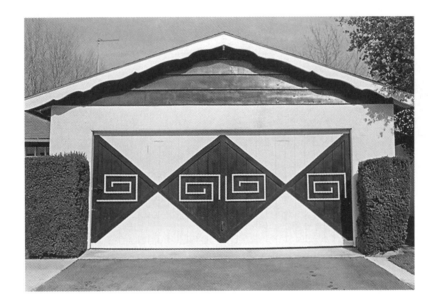

The story of the garage is one of beginnings and endings. In our search for a start we traced the origin of the space back to a footnote in a Frank Lloyd Wright biography. The closer we got to its genesis the more the story unraveled. It unfolded as a kind of conspiracy. The characters who occupied the space began to connect with one another across time, as they adopted their garage as a platform from which to perform and revise their own history while inventing a future.

Built for the car, the garage was a new room in the household that would fulfill its raison d'être for only a couple of hours a day. Unlike the bedroom or kitchen—which sheltered static pieces of furniture like the emotionally charged monogamous double bed or the enslaving oven—the car was never truly at home in the garage. Once the machine was taken outside, onto the street, the garage was cleansed of its original purpose, leaving an emptiness behind that was waiting to be occupied. Physically it is the only room in the household that reaches out onto the street, a threshold between the heteronormative space of reproduction and the productive spaces of the city, a semi-domestic chamber away from the emotional pressures of the private familial realm and the social demands of professionalism. Its ubiquitous presence in mass media, films, books, and personal narratives leaves us with a paraphernalia of illusion, the dismantling of which has no effect on its existence in the cultural consciousness.

The garage of today goes beyond the walls that define it. It is a Duchampian readymade, culturally constructed by its symbolism, with an obscure and fabricated mythology. Harboring murderers and entrepreneurs, the garage exists as a space where the rules and relations inherent in the suburban home are seemingly absent. The garage hid the dark and obscene behind the veil of its automatic door, functioning as a closet for white masculinity, where the real personality of the home was stored.

The garage allowed for the individual to further alienate himself from the suburban myth of the perfect American family. The room carved a space for the outsider to fight against the codes, norms, and aesthetics imposed upon him by the institution of the home. The attitudes that emerged from the garage, less punk than queer, displaced the domestic. The room became an alternative space in which the occupier could escape the constraints of the family home, yet by revealing its function they also reinforced its signifiers. From the suburban project in the Great Depression to the bursting of the dot-com bubble, the symbolic value of the home has been exploited as a tool for economic reinvigoration. The home proliferates as an interior image dragging along outdated typologies that bring with them old models of ownership, gender, permanence, and labor inherited from the postwar era.

In a Benjaminian delusion, we have taken the garage to be the most important architectural form of the twentieth century, which has allowed us to use this vestigial typology to describe the rise of a Fordist society and its postindustrial decline. Walter Benjamin used the arcade as a prism through which he could observe the *flaneur;* here the garage acts as a vehicle to deconstruct the entrepreneur and the radical individual. Our dive into history should not be misread as a desire to return to simpler times, but seen as a way to understand and access our present condition.

The garage is an institution built upon an infrastructure of images. The proto-garage, the stable, was depicted in nativity scenes as the birthplace of Christianity, and as it transformed into the attached garage it has since been painted as the Eden of Silicon Valley, Disney, and Nirvana. From Bill Gates to Gwen Stefani, new American heroes thirsty for neoliberal liquidity were sheltered by this space. In their process of *garageifcation* these characters also became an image that seemingly overthrows an established order; obsessed with the power of their self-mythologizing they built their identity creating fictions more powerful than facts. In the garage, truth becomes irrelevant.

(FOLLOWING SPREADS)

The garage has come to define the twentieth century as the space for invention, from Frank Lloyd Wright's Robie House, in which the garage was first attached to the home, to becoming the architectural technology by which suburbia and its family could proliferate in the American landscape. The garage has also defined the new corporate aesthetic of domestic signifiers in the office landscape as explored by åyr in their project, *Comfort Zone*. The tongue, a sculpture by Olivia Erlanger entitled *Rip*, considers the cow tongue as a force changing the ecology and structure of the American heartland, and is used as a signifier of consumption.

Photographs of garage doors from John Divola's 1970s San Fernando Valley Series, Lorenzo Costa's nativity scene depicting the birth of Christ in a stable. A picture from an installation in a startup incubator by Olivia Erlanger and Luis Ortega Govela showing a teenage kiss in a photograph held down by a lavender dumbbell. Mood board by Luis Ortega Govela.

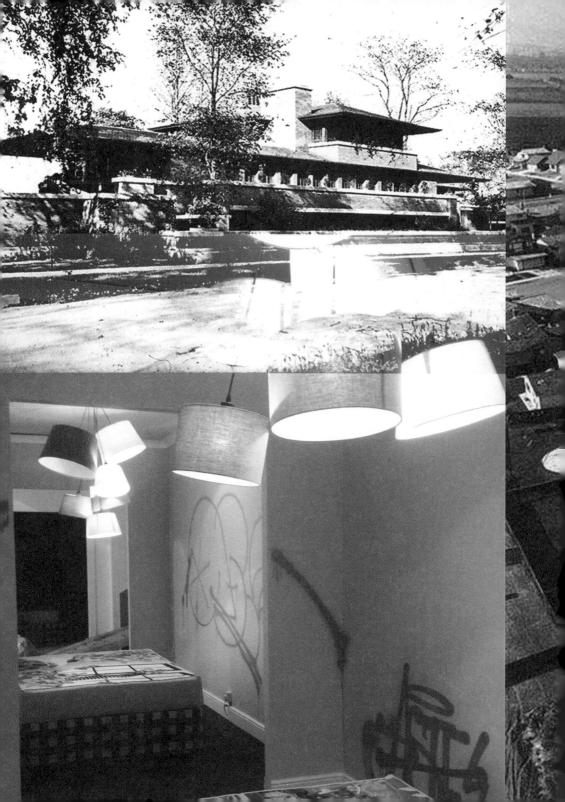

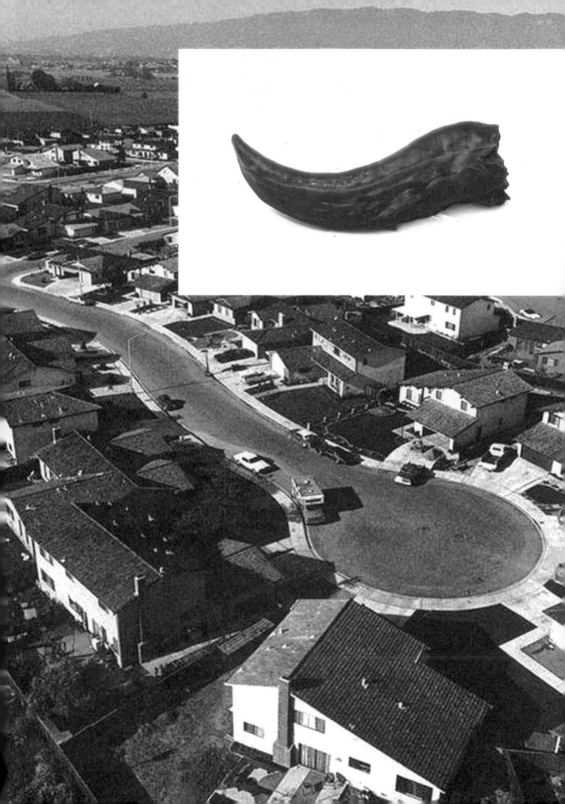

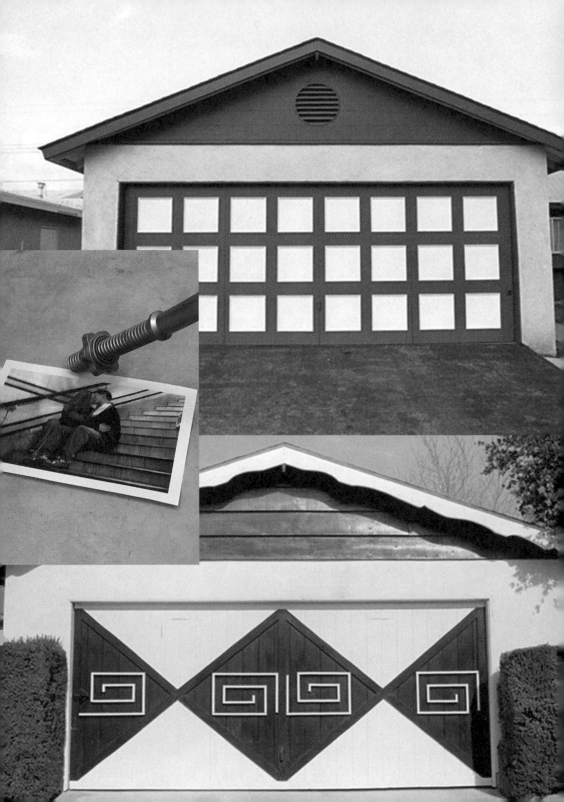

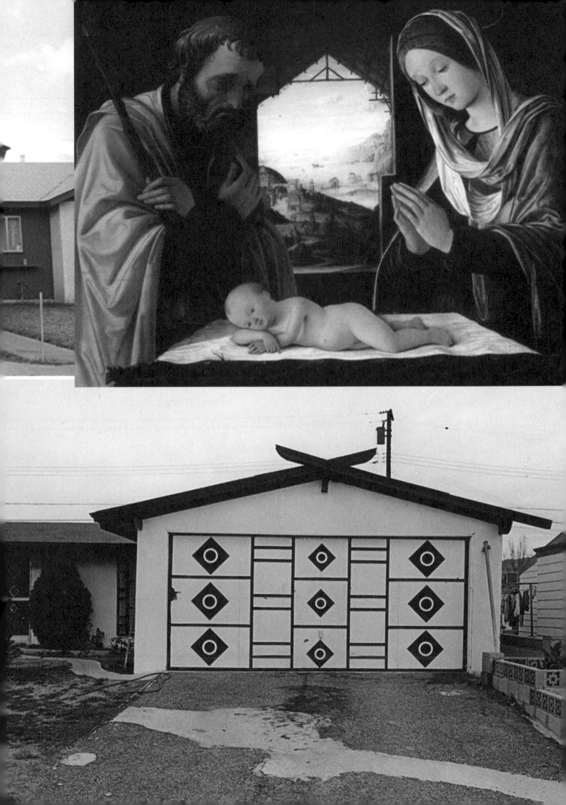

The garage myth is based on concepts of self-reliance and individualism that have become inscribed in the cul-de-sacs of suburbia. In writing a history of the garage that encompassed the creation of the American hero we fell into the traps that we were trying to criticize; we couldn't cope with our offspring. Who owns this? Could it ever be mine? What does it mean to be ours? For a long time, we were working like suburban neighbors, separated by a tiny strip of concrete as we mowed our lawns at the same time; muffled by the noise we inspected one another's handiwork. We had become caricatures of the characters we despised: the entrepreneur who claims it all for himself, a single (wo)man who promotes the god-like delusion of genesis and creation, aka the hyper-individual.

The book started with two separate ideas. One was a sculpture that presented the garage door as a symbol of a declining American middle class and the emergence of Silicon Valley. Isolated within a gallery space, a Craigslist garage door was pierced and drilled through as animal fat dripped from its holes. The other was Hate Suburbia, a thesis written at the Architectural Association that connected the invention of the garage to Frank Lloyd Wright and the start of the of the modern movement in architecture; it followed the transformation of the garage into an incubator for entrepreneurial labor and as a central figure of the foreclosure crises of 2008. It was a queer-Marxist reading of the garage that sought to understand the loop in which conservatism and counterculture continuously fed back into one another.

These two visions, that of the sculptor and that of the architect, come together in this book. Exhausted by our egos we yielded to the garage as a space that demands a certain suspension of disbelief. Giving up the boundaries of self, we allowed one another to write over, edit, add to, and at times completely remove the other from writing. We assembled the book as an

exquisite corpse in which our "we" became an "I." We entered into the image of the garage and the suburban delusion, collapsing into the space by creating our own mythology. We've championed the space, becoming products of its power, at times existing as the heroes of its allure and at other times as its villains. Ultimately *Garage* is not a book about garages but about the power of constructing a space for fluid otherness.

We are two to whom the suburban dream was not sold; our voice was what suburbia was designed to keep out: Mexican, Jewish, female, and queer. Our "we" is able to enter the psychosis that is the American suburb both from within it and outside of it. The third voice created from our two perspectives, the voice that wrote this book, speaks across both subjective experience and memory. Olivia grew up in American suburbia, crashing through the garage door at thirteen, while Luis was baptized in his grandma's garage and came to know suburbia from across an invisible border in northern Mexico, consuming its aspirational image through films and TV shows. We were suspicious of the garage door; the desire to examine was less about penetrating the space and more to do with entering the interior of its image, an approach we have come to define as hardcore realism.

This book was written across seven cities. Writing at times separately and at times together we found ourselves in: a tech incubator turned artist residency at Rupert, in Vilnius; drinking Mezcal while wearing Gabriel Garcia Marquez boots in Mexico City; in Airbnbs or sublets between London and New York City; haunted by the ghost of Charles-Édouard in Unité d'Habitation in Marseille; and even living in J. G. Ballard's one-time home in Shanghai. We occupied the subject we were trying to depict. We garageified the spaces we found ourselves within to turn them into workshops, writer's rooms, and studios. In these flexible spaces that were not

our own we shared notes and edits over Google Docs, reading to one another on Skype or Facetime, editing in real time but almost always apart.

It wasn't until we both were in Los Angeles in the summer of 2017 that we began writing together in a city that was more sub than urban. Our physical proximity in many ways pushed us further from one another. Like long-distance lovers meeting again in real life, the reality of the other, rather than the digital clarity of the voice of the phantom collaborator, proved too much. It took months to adjust to sharing physical space as we had grown used to the imagined version of the other. It is always easier to love from afar than to face the tangled mess of negotiating the boundaries of what it means to be together IRL.

The garage project addresses many duos, from Frederick Robie and Frank Lloyd Wright to Steve Jobs and Steve Wozniak, to Gwen Stefani and Tony Kanal. In these stories two people come together to create something new. From brand to business to art, the classic narrative is that eventually, in a Frankensteinian nightmare, creation absorbs creator. For all, the garage was the space in which their love and private life became an enterprise. Once the private relationships between Woz and Jobs became an IPO and the intimacy between Gwen and bassist Tony Kanal was exploited, the partnerships fell apart. The machine of what they began could not be stopped: what they owned ended up owning them. The struggle we faced in creating this book is the same as what these characters faced: how to maintain individuality as you become subsumed by the collaboration.

And yet, the real struggle has been to stay together to fight history's desire to revise our narrative into the singular, uplifting one voice over the other. The creation myth and ascension of the average Joe is always more tantalizing than that of the whole, and as these stories are retold they re-create the individual rather than the organization of people that

contributed. The collective is what fuels new subcultures and inspires invention. What we have built is based on friendship rather than business. The idea of companies spontaneously growing inside garages while you hang out with your buddies is a huge misconception. Apple, Hewlett-Packard, Google, and Amazon all started as organizations that wanted to produce monetary value. The notion of companies emerging from white males tooling around with each other is a pervasive myth that implies that fun is necessary for the production of capital, portraying a blasé affair in which the people involved don't want or need financial success.

Simultaneously with writing this book, we began our study of the garage by opening the door and exploring what was hidden behind it. In the real spaces of friends and strangers we began to distort reality by adapting our words into a documentary. As we began filming, we breached the threshold, going into our subject's homes and garages. The stories and people we found are Americans, hardcore capitalist punks, and they exceeded our assumptions of what we thought the free space of the garage could provide. They broke through our garage door and showed us that the reality of America is a spikier and more complex ecology than we could've ever imagined.

In the process of painting a contemporary portrait of suburbia we discovered identities that contested the norm, finding teenage lava lamp lairs, weed-growing nuns, BDSM crucifixions, blues garages, and garage-band historians. And as much as the images of Gwen Stefani, Kurt Cobain, and Kevin Spacey have affected our perception of the space, these people collapsed the image we thought we understood by taking their subversion further than any cult icon had before. In filming these individuals on cameras and iPhones, we found that our preconceptions of the garage's potential were pulverized, and instead we encountered an entanglement of

identities the mere existence of which collapsed the image of the garage we thought we knew. Yes, our minds were blown.

The garage is the most mundane of architectures. While it was never intended to stand as a monument, in the following pages we construct it as an icon of the American Delusion. Born out of the cis-male dominated modernist movement in architecture, the garage now acts a vessel for the current crises in masculinity. The garage's history simultaneously describes the privilege and excess of space that is offered to whiteness while containing histories of antagonism. It is a space of initiation and transition, the sacred space where characters can fight against the context that surrounds them to construct themselves anew: a temple to the self. Despite its foul history, it is a space that helped to rewrite systems of production, to expand ways of thinking, and it acted as a new ground for identities to evolve within. Inside the garage one can always resist the surrounding world and become *other*.

# THE **WRIGHT HISTORY OF**
# **THE GARAGE**

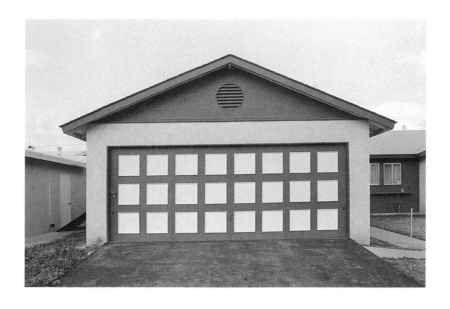

**"In this story, I am God."** FRANK LLOYD WRIGHT

I was looking for the first garage.

At the age of fourteen, Frank Lloyd Wright was abandoned by his father. Later in life, when he moved to Chicago to become an architect, he was hired by Louis Sullivan, the "father of the skyscraper." While his mentor was creating the capitalist extrusion of the high-rise steel tower, Frank was working on Sullivan's private home commissions. It was here that Wright became devoted to the construction of a domestic architecture that would champion heteronormative virtues and glorify the idea of a nuclear family. As with many before and after him, his unresolved traumas bled into his work. The ghost of Wright's absent father haunts his home designs, revealing how the misconstruction of manhood as patriarchal is as abusive of others as it is to the self.

Over time, Sullivan and Wright became friends, and when Wright was ready to set down roots, Sullivan gave him a loan to build a home for his wife and six children. This house would mark the first time Wright would work outside of his mentor's gaze, and with this freedom he created a new definition for the structure of the home, an alternative that would transcend the personal to become a new American vernacular. He named it the Prairie.

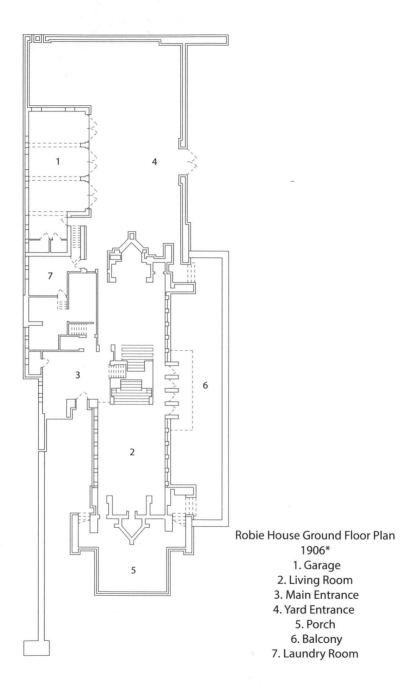

Robie House floor plan as drawn by Luis Ortega Govela.

Robie House Ground Floor Plan
1906*
1. Garage
2. Living Room
3. Main Entrance
4. Yard Entrance
5. Porch
6. Balcony
7. Laundry Room

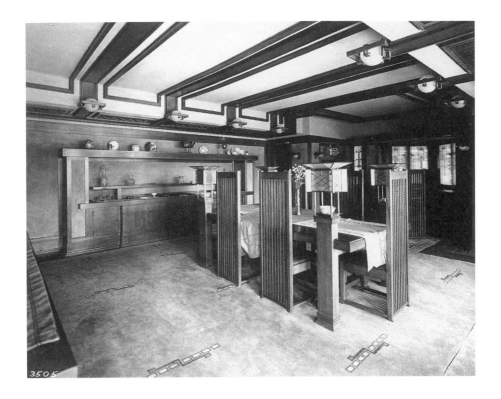

The Robie House dining room
with original furniture designed
by Frank Lloyd Wright.

This first domestic project—his own home—was built on a plot of land
in Oak Park, a quaint residential area—a weird choice for the person who
would be regarded as the most radical architect of his time. The neighbor-
hood, full of traditional Victorian homes and overtly formalized family
structures, was a suburb that, for Wright, appeared as fertile territory upon
which he could experiment with a new style for the American home.

Wright's self-righteous mission was to sanctify traditional family values, but reconfigured within an updated representation of home design. Wright physicalized his own projection of a perfect domestic life, his lack of male role models actualized within the space of his first residential projects.

Constructed out of low horizontal planes that were based on intersecting Froebel geometries, the Prairie-style house was, in essence, the formal contra to his mentor's creation. It was reactionary. As he watched Chicago and its skyline transform vertically its density also transformed, with more and more people moving in the streets trying to be close to these pinnacles of capitalism. The Prairie-style house was to stand in opposition to the *shared building*, the tower protruding out of the growing urban landscape. It was meant to be a camouflaged construction that hid in its surroundings, where neighbors were not forced to share walls or floors. It was to be a pastoral setting, meant to fuse nature and architecture.

In the aftermath of his failed transportation building in White City at the 1893 Chicago World's Fair, Sullivan's career came tumbling down, at the same time as Wright's was taking off. The Prairie-style house rose from the ashes of Sullivan's ruin at the World's Fair, and with it Wright created the first typology adequate for an emerging middle class.

Before the Prairie house, the typical American home attempted to copy the classical formality of a Greek temple. Without its own myths to construct upon, the American home appropriated and repurposed the forms of previous cultures unto a virgin land. These homes, built in the Greek Revival style, functioned as conglomerates of institutions that had yet to be privatized for financial gain and separated from the domestic sphere: schools, churches, charities, hospitals, orphanages, retirement homes, farms, and welfare agencies all resided within its walls. The decorated sheds with temple-fronted facades adopted pediments and columned

porticos as a way to bring an order and an appearance of decorum to the multifarious functions that hid behind.

(FOLLOWING SPREAD)

Frank Lloyd Wright's domestic architectures were designed around Emersonian philosophies of self-reliance. Another tool that helped Wright develop the Prairie style was his Froebel block set given to him by his mother when he was a child.

Wright thought this style was vulgar. In the Prairie-style house he stripped away the columns, central entryways, parlors, and redundant rooms. When Wright moved to Oak Park it was the beginning of a new century in America and the needs of its citizens were changing; just as the columns, central entryways, and parlors lost their relevance, so too did the need for the family unit to function as a hygienic protective structure. Thanks to industrialized sanitation and modern antibiotics the threat of disease was no longer clouding consciousness, and a new type of American was being constructed upon a sterilized democratic landscape.

Wright's own Oak Park Studio was the first Prairie house, a model home built to attract clients. In a sense, Wright was providing his clients with more than a life-sized maquette; he was providing a blueprint for his "ideal way of life." This studio house proposed a typology of home that was neither an urban row house nor a rural farmhouse. It was a house for a new kind of family, one that deviated from the conventions of the European nineteenth-century bourgeois stately home. Wright wanted to get rid of the Victorian preoccupation with social status and display. His drive was toward purity, minimalism, smooth surfaces, straight lines, and sharp angles. It was precise and honest in its materiality. These designs were the early stages of modernism.

Wright was developing a home-grown American architecture, one that reflected the fight for independence from both Europe and European creative influence. It was the duty of the new American architect to remedy the social contagion brought on by modern industrialism, which produced not only ugly furniture but also family homes marked by fracture and alienation.

Initially Wright belonged to the Arts and Crafts movement, which quintessentially refused to operate within the newly industrialized

processes of machine-made objects. Later, at the turn of the century, he switched gears, as epitomized in his 1901 speech "The Art and Craft of the Machine," which was the first defiant, unabashed embracing of mechanization by an American architect. He exclaimed that

in the years which have been devoted in my own life to working out in stubborn materials a feeling for the beautiful, in the vortex of distorted complex conditions, a hope has grown stronger with the experience of each year, amounting now to a gradually deepening conviction that in the Machine lies the only future of art and craft—as I believe, a glorious future; that the Machine is, in fact, the metamorphosis of ancient art and craft; that we are at last face to face with the machine—the modern Sphinx—whose riddle the artist must solve if he would that art live—for his nature holds the key.

Even though he was applauding the machine, strategically positioning himself against the core values of the movement that he had helped found, the Arts and Crafts ideology remained in his designs, especially those tied to marriage and home life. It was an outwardly hypocritical approach but one that served his private agenda and self-righteous moral code.

Wright was an architect with Emersonian ideals; that is to say he lived for individualism and self-realization. He was creating a new brand of democracy, in which his stance against the Greek Revival style was both aesthetic and political. He hated ersatz Americana, as he opposed the practice of transferring building types across cultures, the results of which he considered to be scatological imitations. Despite his harsh criticism, Wright would later commit the same cultural crimes in his Japonica and Mayan phase by appropriating other cultures' architectural languages in pursuit of a real American vernacular.

For the creation of this new typology, Wright went back to his childhood, revisiting a gift he received from his mother that he would later credit as the source of his spatial awareness: a Froebel block set. It was an

Oedipal twist in his attempt to deal with his father complex. This was his principal design tool, and most of his first homes were recompositions of those rectangular geometries that created low-lying masonry structures tied to the native landscape, with cantilevered roofs. Built from brick, the vertical mortar joints had been reduced to accentuate the horizontal ones. This was a tactic Wright developed to make it seem as if the home were built entirely from very thin slabs of red stone that unified the brick construction and aesthetically subjugated its modularity, making it seem as if it had grown naturally from the ground. The idea was to abolish the box, as seen in those square and cramped cubicles that too often characterized American interior design, and to promote convenience, freedom of movement, and togetherness. His Prairie-style houses quickly found a pool of clients who resembled people in Wright's own life: Unitarian suburbanites with an Emersonian bent.

If the homes previously relied on a patriarchal structure, in which the father would delegate the responsibilities of the household, Wright's paternal lack fueled a matriarchal structure in his family clan. Wright's mother, Anna Lloyd Jones, was a powerful female figure whose presence gave him insight into how women could be active in both domestic and waged labor. At the same time, new technologies were entering the home, such as the washing machine, baking products, and the sewing machine, which reduced the time and space needed for household chores and created a new culture of consumption. Wright's architecture attempted to combine all of these elements into a cohesive whole that represented a rupture with both a personal and a societal past and contributed to the construction of the American Dream. While he was constructing said dream, corporate America was fueling a self-interested revolution in communication through aggressive advertising in newspapers. With each paper being

tossed across white picket fences, corporate interests were literally left lying on the front lawns one step closer to the home.

The Robie House, like most other Prairie homes, is characterized by the use of red masonry brick. In an effort to make the houses appear as if emerging from the ground, Wright created his own bond in which the horizontal mortar joints were emphasized by reducing the vertical ones. Superimposed onto the brick texture are photographs of Louis Sullivan's Transportation Building at the World's Fair, known to be the failure of his career and the beginning of Wright's, when Wright was Sullivan's apprentice.

# THE **ATTACHED GARAGE**

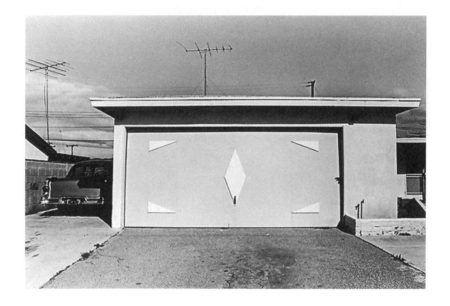

In 1905 Frederick Robie, a young entrepreneur and son of a bicycle manufacturer, met with Wright on his wife Lora's insistence. Lora wanted their newlywed home to be designed by the architect after reading his proposal for the new family home in the latest issue of *House Beautiful*. Robie had caught Wright's attention because of his car, as they were two of the only men in the South Side of Chicago with a gasoline-powered machine. At the time, Wright was driving a customized yellow Stoddard Dayton, while Robie, who was trying to convince his father to transform their company into a car-manufacturing enterprise, had built his own prototype. Lora was one of the first women to drive a car in America. The Robies were from the same pool as Wright's clientele, young families comprising entrepreneurs and first-wave feminists.

Wright's career as an architect coincided with the building of the first American gasoline car in 1893. He became so addicted to owning automobiles that he spent most of his life in debt for this consumption. Technological innovations such as the car are usually met with suspicion by conservative parties keen on maintaining the aesthetic purity of the past. But Wright, seduced by accelerationism, never fell for the pitfalls of nostalgia. And despite the fact that there was, at first, little room in the market for it, Wright understood that the car was going to radically transform the way people occupied and traversed space. This prophetic vision was

actualized when he began his Prairie houses, and he helped shape the significant relationship between home and the automobile. He was proposing a new form of life that would be reliant upon this new technology. At this point in time, only the wealthy could buy cars, and so it was among this social group that the machine's status as a domestic necessity began to take hold. In these stately homes, the car lived, hidden away, in the stable, a detached typology that was physically and psychologically isolated from the rest of the household. The nature of this spatial division would come to define the structure of the garage.

When the Robies came over to discuss their architectural plans, Frank had just finished the Cheney House, his first, failed, attempt at integrating a garage into the main body of the home. Wright wanted to diminish the distance between house and car. It was logical to him that the automobile's space was to be integrated into the main structure of the house. Not only would this mean that the machine would formally be part of the family, but functionally it would further ease mobility. The plan was to construct a basement, his least favorite room in the home, as a parking space for the car. Regardless, the city council rejected the plans over and over again; bringing the gas-powered machine into the home was an alien idea, not easily envisioned by bureaucrats. The construction industry and society at large were reluctant to embrace the motorized version of the horse-drawn carriage. Sleeping next to the machine, with its fumes, odors, noises, and dirt, was impractical and went against building and fire regulations. Without highways, roads, garages, or gas stations, the new carriage was more a toy than a tool. Thus when the car first appeared on the market there was not much use for it. Vetoed by the city, Wright's project was hindered by the monotony of planning departments, and the home was finished

without its basement garage. Instead of giving up hope, Wright set himself on the mission to find a project in which he could resolve his frustrations.

When it comes to Wright, it is hard to separate myth from reality; he would lie in order to construct a new image of himself and his projects. There are always two conflicting versions: the one that he supported and believed, and the one that emerged post mortem and after fact checking. From changing his birthdate to rewriting the year in which the first attached garage was built, Wright's paranoiac fabrication of his history was something the he practiced throughout his life. He rejected facts in order to create a coherent and meaningful fiction that allowed him to repudiate architectural conventions, thus asserting his own dominance over twentieth-century architecture. It is a biography ripe with paradox and nonlinearity.

According to Frank Lloyd Wright's version of events, the car and the home were integrated in 1908, a few months before the release of Ford's Model T, the first affordable car produced on an assembly line. The Model T popularized car ownership in America and Wright, obsessed with this new technology, called for its full integration with the rest of the house and its inhabitants. Suburban enclaves were places for people who had chauffeurs and horse-drawn carriages and could afford the trips back and forth from urban centers to the periphery; once Ford released the Model T this all changed. By attaching the garage to the home, Wright architecturally explored America's emerging relationship to the car. By placing it at the front of the plot as part of its main facade, the statement was clear: the car was central to the home. It no longer had to be stored in a communal garage somewhere or hidden in the stable; the car had become a member of the family.

The standard American house was normally divided into many separate rooms; cramped, cluttered, inflexible, and fragmented, the layout forced a compartmentalized existence that required more floor area than Wright wanted to provide, or pay for. He scrapped the traditional model and began centralizing functions into an open floor plan. The car allowed for an existence outside of the home; thus there was no need for this amount of space and its division. In comparison to the houses around them, Wright's appeared alarmingly small. These other homes had to host rooms and functions that were no longer fashionable or functional, so the Prairie designs seemed reduced; Wright had boiled down the American home to its core. A key factor in these changes was the emancipation of slaves at the end of the nineteenth century, and Wright's vision for this new suburbia did not include space for carriages, servants, basements, or attics; he was creating a new vernacular that both aesthetically and functionally presented a grand domestic revolution.

These early models reflected a new way of life that would be absorbed by mainstream culture during the spread of suburbia thirty years later. But it was also appropriated by a group of Mitteleuropeans—Walter Gropius, Le Corbusier, and Ludwig Mies van der Rohe—who were coworkers at Peter Behrens's studio. According to architectural folklore, when *The Wasmuth Portfolio,* a monograph of his Prairie projects and Wright's first published book in Germany, arrived at Behrens's office, everything came to a halt. The whole office was so shook that work was canceled so they all could pour over its pages. The set of a hundred drawings of Wright's typology and ideas behind the open plan directly influenced this new generation of architects. In Wright, the expansion of suburbia seems to run in parallel with the dispersion of the modern movement. Yet Wright's

antagonism forever distanced him from his peers; he rejected them as much as they appropriated and admired him.

Wright modeled suburbia after his own vision of family life, and his fantasy became (and spread) as reality. Yet it was in the design of the Robie House rather than his own that the most radical ideas around the Prairie house were realized. The integrated garage alongside the other architectural proposals Wright carried out in the project mark a distinct departure from the architecture of his time. Wright prescriptively removed the front porch, parlor, and closet spaces from the home, and he proposed an attached garage, which would eventually absorb and replace them all. The rooms that he banned from the home would later colonize the house as the garage lost its purpose and became a deprogrammed architecture acting as a repository of the lost functions in the modern home.

**THE FRONT PORCH**

Looking up the Robie House on Google street view has become a ritual; each time one hopes to find something different, something that would reveal its radical nature. Instead, the pixels show nothing more than a gray paved street and a corner plot, overshadowed by the surrounding University of Chicago buildings. Seen in person, the Robie House refuses the visit—it is the most unwelcoming of houses; looking at it next to historical images of Oak Park from the time of its construction you realize that the Robie House does not look like a home. It has always existed as an odd construction that longs not to fit in.

Hidden under the shadow of a cantilever, the Robie House wraps around the corner of East 48th Street and Woodlawn Avenue. Unlike the rest of the houses on the block, the Robie House lacks a traditional street facade. Ever subverting architectural standards, Wright plays a game: he

places the front door on the west elevation, forcing visitors to enter from the rear. Swallowed deep inside the short facade, the backward entrance is designed to confuse and to strip the main entrance of "the curse of the American home": the front porch. The Wrightian trick employed here is that the porch isn't actually removed; rather, it is raised to the first floor and relocated to the short facade. Towering next to the main entrance, it functions as a balcony, enforcing a distance between resident and neighbor that the traditional front porch was built to shorten.

The porch was invented as an architectural technology whose function was to mediate between the intimacy of the home and the street. It was a buffer zone, with a permeable border; a neighbor could climb its steps, apple pie in hand, to gossip, building a sense of the commons. In the Robie House, the transition from front porch to balcony complicated the social nature of the neighborhood. Not only were the flat cantilevered red brick rectangles standing in opposition to the pitched roofs of the area, but Wright's reinvented porch exuded a sense of secrecy and false superiority, one that frustrated the community so much that they accused Wright of building a brothel. Perhaps the neighbors understood that a change of this nature was so jarring that it had the ability to shift suburbia on a fundamental level, codifying a set of rules for domestic life that would unhinge those that they lived by.

Further distancing the Robie House from its streetmates, Wright changed the height of the brick boundary walls that demarcated the home's edges. The standard practice was to build them at hip height, but Wright demanded that they be raised, prioritizing privacy and deepening the chasm of suburban division. In doing so, the Robies were freed of codes of conduct imposed by out-of-date typologies that reflected an older generation's way of life that Wright found constricting for the

creation of a future. Wright wanted to reinforce the notion of a strong single-family unit, thereby presenting an individualized way of life. This border wall impeded the suburban schadenfreude by keeping things hidden and neighbors guessing.

Wright weaves an opposing narrative across the long facade of the Robie House. On the side facing Woodlawn Avenue, the building appears inviting, pierced with windows, or "light screens" as Wright liked to call them. Its perimeter runs along the sidewalk and the brick boundary wall is punctured with a hole framed by a concrete lintel, extending over a wrought-iron gate. The gate itself, mirroring but blowing up the leaded glass window patterns, guards the drive, and leads to Wright's solution for a porch-less home: the three-car garage. The Robies, liberated from neighborly conditions, were able to renegotiate their relationship between the private and the public within the domestic through their car. The garage was a new threshold that could be closed off or opened at will, a ritual in which the family and home were no longer connected to the neighborhood outside; rather, the garage and the car opened the home to the modern city.

## THE CLOSET

Any house is a far too complicated, clumsy, fussy, mechanical counterfeit of the human body. Electric wiring for a nervous system, plumbing for bowels, heating system and fireplaces for arteries and heart, and windows for eyes, nose, and lungs generally. The structure of the house, too, is a kind of cellular tissue stuck full of bones, complex now, as the confusion of bedlam and all beside. The whole interior is a kind of stomach that attempts to digest objects—objects, objets d'art maybe, but objects always. There the affected affliction sits ever hungry—for ever more objects— or plethoric with over plenty. The whole life of the average house, it seems, is a sort of indigestion. A body in ill repair, suffering indisposition—constant tinkering and doctoring to keep alive. It is a marvel we its infestors do not go insane in it and with it. Perhaps it is a form of insanity we have put into it.

Wright wrote this the same year he finished the construction of the Robie House, in his essay "The Cardboard House." It was another stab in the age-old battle between architect and housewife.

Wright attacked the need for dark closet spaces. For him, the home should not be a junkyard; it should avoid having any poorly ventilated or dark rooms "to pack things out of sight." This cleansing prescription that Wright carried out in the Robie House and the rest of his Prairie homes was the basis of the modernist desire toward abstraction and minimalism: a life without objects. Without closet spaces, the home and the housewife lost the nooks and crannies where the storage of disused objects could take place.

Closets contain secrets, and a home bereft of them meant these were left exposed. Closets can act as portals to enter small private worlds of supplies or excess. Previously, closets would have hidden provisions for the family, from bed linens or clothing to serving objects, stores for the winter; without closets there would be overflow in the home. If before the rural home was a self-sustained unit like a farmhouse where the production of clothes to the upkeep of animals happened within its walls, with the introduction of the garage the suburban home became autonomous from its surroundings and dependent on the car. The home became a repository and display of a family's consumption.

The introduction of the car into daily life accelerated the speed of consumption. Wright's effort toward removing objects was in vain. The Robies, in need of even more closet space than they had before, started using a corner of their oversized garage. Decades later, once the garage had evolved to be an appendage to almost every suburban American home, the space started performing as the biggest storage room in the house. In the latter half of the twentieth century, the garage became the de facto space of the

hoarder, the American consumer's preferred landfill. From old Legos, fishing rods, and ladders, to bikes, flotation devices, and old family albums—anything and everything that could be saved for later found a home there. This devouring and collecting of goods hidden behind the garage door evicted the car and replaced it with cardboard boxes and containers holding mounds of forgotten household objects. As Wright rid the home of interior closet spaces, the home then spat out the refuse for which there was no allotted space—one step closer to the street—into the garage.

## THE PARLOR

Wright formed the Prairie style as an antidote to the Victorian house and its ideas of inclusion/exclusion. The Victorian home had a silent air of seriousness that Wright wished to dismantle. Thus, in "In the Cause of Architecture," Wright claimed the need for a new type of room for everyday life based on America's newfound individualism, a room that would fulfill the needs of a new *byt* lived in greater independence and seclusion and that would successfully replace the parlor as a reception room for public display. He explained that the parlor was an intermediate area between external life and the family, a buffer zone like the front porch, but one with an added level of intimacy for performance of societal and gender roles.

The parlor exposed an image of the home by dividing the house into semi-public and intimate spaces. For Wright to be able to remove it from the plan required the introduction of a more internalized room for the family, a nebulous all-purpose room with a symbolic fire at its core, which Wright would call the hearth: a living room.

Part social gathering space, part living space, the living room became part of the home at the same time as the garage was attached to the

household. Around this time the telephone and radio were also introduced, allowing the outside world to encroach on the insular familial domain. Phone calls connecting family to friends and an outside network could take place, news and radio talk shows could be tuned into, and a world previously held at bay was invited into the home.

Although the living room had previously existed as the hall in medieval typologies, Wright claimed it as his own invention in the Robie House, fabricating further his involvement in innovating American home design. In the case of the Robie House, the three-car garage and the multipurpose room shared the same footprint and were a reflection of each other in scale.

The Robies' living room was the only deprogrammed space in the home. If previously particular rooms in the household were justified through the very specific functions they had to carry out, the genesis of the living room counteracted this. Intentionally functionless, the living room became a fluid space within which dwellers could live out their own sets of etiquette and use. This freedom also came with the downside of constant internal surveillance and control. A family that does so much of its living in one room must be either extraordinarily harmonious or very well trained by whoever holds the reins of power.

Wright, in his attempt at creating space for the father figure he never had, embedded the patriarch in his design process, most of the time ignoring the needs of the other family members. In the Robie House, the rooms were designed with Frederick in mind; with his three-car garage, master bedroom, and personal study shrinking the size of the kitchen and his children's room, it was clear that the home was his, and his alone. Thus, the living room was as freeing for him as it was oppressive for the rest of the family. Without a room for themselves the rest of the family was left tiptoeing around the place. The blatancy with which the house honored Frederick highlights the likelihood that Mrs. Robie's decision to leave

Frederick two years after moving into their home was influenced by Wright's design.

Twenty years after the completion of the Robie House, the previously functionless space of the living room was finally given a purpose with the invention of a new machine, the TV. Although the telephone and radio did adjust behavior in the space, the living room retained its freedom; but once the television was placed in front of the couch, providing something to watch, a new set of interactions evolved. Visual media became a family member, and a dominating one at that. The family, now remote controlled, lacked a deprogrammed space within the home.

The parallels between living room and garage go beyond their similarities in scale. Both are spaces whose functions were dictated by man and his machines—the TV in the former and the car in the latter. Both rooms acted as repositories for symbolic and physical movement; the television allowed for surfing across time and narratives, between spaces, and the car allowed for driving through space. Whereas the TV remained a fixture in the living room, in the garage the car could be removed, making it into a deprogrammed space that began to operate like the early living room. It was an empty shell without function or use, a space where the inhabitant could set his own rules and ways of being. Wright had meticulously planned the living room as a fluid space in which functions overlapped; with the introduction of television into the home and the weatherization of the car, these social programs were swallowed by the garage.

## THE DETACHED GARAGE

In the quiet darkness of South Woodlawn Avenue, Frank Lloyd Wright molded and adapted the American home for the automobile. The small rectangular windows of Wright's Robie House cast rectilinear shadows

across the sidewalk. In the moonlight, the red hydrangeas lining the second-floor balcony appeared black, to be identified only by their smell. With no "front" or "back," the building looms, imperious and totemic. To the pedestrian it looks like a Japanese woodblock puzzle: the riddle of how to enter, or exit, persists until one encounters an oversized gate leading to a three-car garage. The Robie House is known by many as the cornerstone of modernism, but its status as the first home with an attached garage seems to have been forgotten. The garage struck architectural academics as so banal that it became nothing more than a footnote in Wright's illustrious history.

The garage was invented to domesticate the car. At the end of the nineteenth century, the car made its entrance into the stage of history to replace the horse. Initially it was a temperamental machine, and people were reluctant to incorporate it into their daily lives. The machine had yet to develop the technology necessary to be used regularly, so it was mostly kept in the stable, next to the other animals. Yet at the same time the car needed so much upkeep that mostly they were stored in communal parking lots where the first auto mechanics would constantly be preparing cars for the type of local roads that existed at the time. Without gas stations it was impossible to travel that far. Beyond a practical architectural question of how to design a room for the instrument, the process of integration between house and car speaks to a larger psychology behind homeownership and its connection to the private interests of corporations.

If the human entrance to the house was secretive, the one designed for the machine was not. Inside the yard, the garage doors dominate the space. It is here that the garage claims its rightful position on the front of the plot with a direct and easy connection to the street. Wright, in an attempt to avoid the "especially ugly hole to go in and out" of the house, concealed

the main entrance on the west elevation. If we go by Wright's poetic hand, in 1908 the garage was symbolically integrated into the familial structure. This relationship between home and garage, family and car, would not reappear in architecture until the early 1920s, making the Robie House a premonition of the future.

While the rest of the household is modeled on human proportions, the garage uses the machine for scale. With the car as an instrument of measurement, the home follows a different design. The front entrance becomes a giant door, almost institutional in size. At the same time, if the bathroom and kitchen reflect bodily functions and their standardization, the garage had to provide for the automobile, and ultimately it is this consideration that shaped the space. Closed off, with minimal ventilation, it was a bunker built to keep things locked and hidden. The floor was smooth, unobstructed by columns to improve circulation. Its only entry point was three monstrous doors; above it, servants' quarters. This wasn't radically different from the carriage house except that the machine came to replace the animal.

The progression of the car from hiding in the stable to dominating its main facade in the garage shows the impact that this space had on the construction of the suburban nuclear family. Within the Robie House lies an astonishingly clear account of how the house began to be designed for bodies augmented by machines, cyborgs. But it is also about the cross-pollination between the aesthetics of industrial societies and its domestic life. Simply put, the garage and the car it safeguarded were not only the technologies by which suburbia was created but also the tools that allowed for suburbia to spread like a disease throughout the American landscape. The garage, the appendix of the home, is an indelible link in the chain of expansion.

## A FAILED MODEL (EL CHISME)

Wright's Prairie house was no more—and distinctly no less—than a palpable expression of marital fidelity and idealized domesticity, one that few, and certainly not Wright, could uphold. Monogamy can be tiring, and monogamy with six children in the same household as you and your wife and your studio is an insane endeavor. Wright's kids had become many and noisy; not even the separate studio he had built on the Oak Park property could insulate him from their disruptive forays into his workplace. In addition to his children, creditors seeking repayment on his many loans for his cars began to oppress him. Suburban life itself, once a goal to be achieved and celebrated, now seemed provincial and detrimental to the full expression and fulfillment of his imperial self. So a few months after the completion of the Robie House, Wright began to spiral downward.

Neighbors began to notice his increasingly flamboyant dressing; the capes and large brimmed hats became too much for the quaint residents of Oak Park. His house guests became ever more exotic and even bizarre; the suburb began to reject the avant-garde and its intimidating fabulousness. Rumors were flying of Wright's affairs with previous client' wives, both of whom were radical feminists and restless suburban outsiders: Queene Coonley, with whom he flew to Japan, and his second-wife-to-be, Mamah Cheney. The promise of family unity presented by him and his houses became the perfect concealer for suburban adulterers. Wright was imprisoned within the confines of a fashionable convention of his own making.

It could also be that Wright was just going through that paternal rite of a midlife crises, a nervous breakdown that often presents itself as an actual celebration. He was having fun at the expense of his family, so he ended up doing to the members of his family what had most affected him in his own

childhood: he abandoned them. He repeated his own father's crime, which he had worked so hard to absolve: he ran away from suburbia, escaping the shackles of the nuclear family. His occupation became his life and his buildings became his children. What he owned came to own him. In his autobiography he mentions that "the architect absorbed the father." Wright, no longer wanting to perform his parental role, retreated to Europe with Mamah, leaving behind the reality of the Prairie life he had so meticulously constructed.

Wright's failed first marriage represented for him his final chapter in Oak Park and the end of his architectural exploration of the perfect family. In the process he threw away his twenty-two years of practice. Even though Wright's construction of the family seemed strained by this typology of home, the Prairie houses appeared as islands of stability surrounded by a society in crises. It was a symbol hard to shake off and easily adopted by the government, to be replicated endlessly in the postwar era. Living up to the pressure of his own prescriptions of what life should be was too much for even Wright to handle; nevertheless it became the model that developers used to create suburbia. Suburbia is a space everyone, including Wright, wanted to escape, and the best place to do it was through the biggest door in the house.

(FOLLOWING SPREAD)

Frank Lloyd Wright built his first home in the Prairie style for himself in Oak Park, a quaint residential area of Chicago. After the completion of the Robie House, Wright and his search for the perfect domestic life took a drastic turn when he left his family life behind to go to Japan and continue his career as an architect abroad.

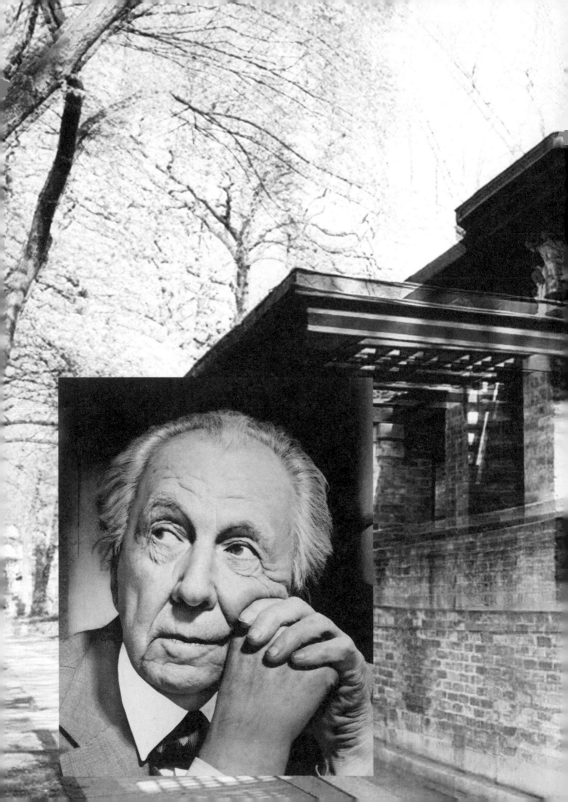

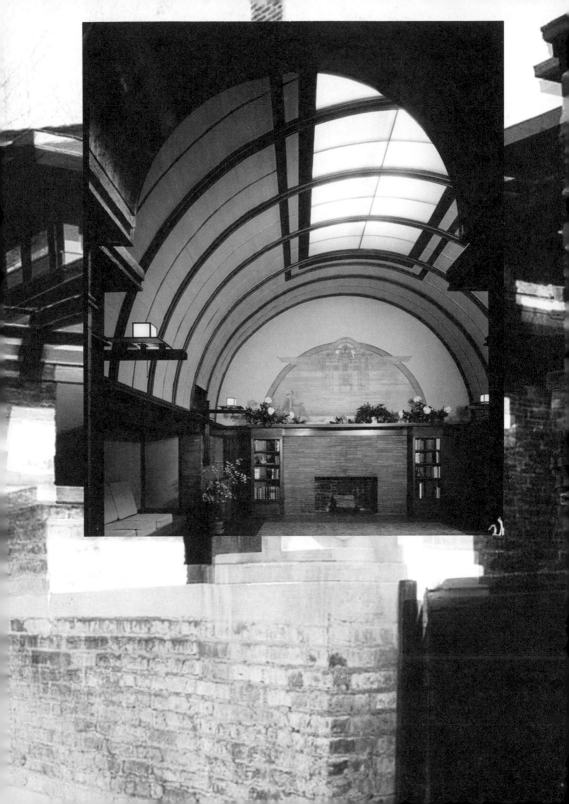

# DOMESTICATION OF **THE GARAGE**

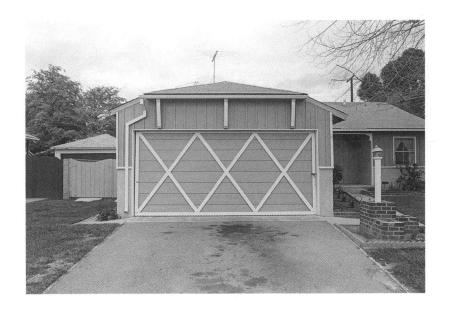

"I have to believe that the time is not so very far distant when the 'American Home' will be really owned by the man who paid for it. It will belong to its site and to the country. It will grow naturally in the light of a finer consideration for the modern opportunity which is a more practicable truth and beauty. An American home will be a product of our time, spiritually and psychically. It will be a great work of art, respected the world over, because of its integrity, its real worth." FRANK LLOYD WRIGHT

The history of the garage tells a story of an architectural technology that has become part of our daily life, while the home itself hoards the secret of its inception. Houses are made from rooms whose functions are dictated by bodily rhythms, circadian, hormonal, and excretory. The skeletal blueprints of where these rooms and machines came from are hidden under a skin of perfectly rendered plaster. To unearth them, one must go room by room, object by object, tracing the hardware back to the bodily and mechanical functions that they were created to accommodate.

The bathroom was originally a bucket in a corner of a bedroom and later became formalized through a hygienic concern into a series of pipes and ceramic addendums that allowed for an ergonomic way of handling digestion and cleanliness. Since its invention it is impossible to have a

house without one. In the same manner, bedrooms were usually shared by families, one bed for all, and as bed sizes became standardized into the monogamous double bed, the size of the room changed; its purpose was no longer just for rest but for reproduction and recreation. Similarly, the garage came to be because of the car, and this technology had to wiggle its way into the structure of the home. Walls had to be ripped open, to be piped and wired to begin the process of domestication, of making a piece of hardware part of the inhabitants' daily life. Technological innovations like these not only changed the typology of the home, they also redefined its meaning and character, introducing strange noises like dripping taps and electric buzzing, rhythms that introduced new patterns of work. In the endless search for comfort, each new innovation is added onto the frame of the home and presented as a given so that they are rarely questioned.

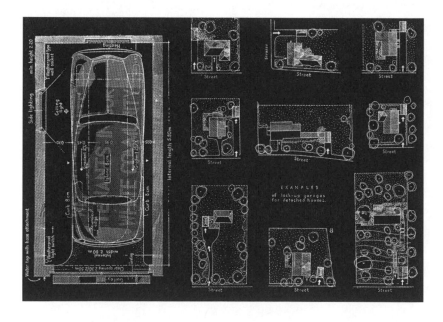

Initially the garage was meant to be fully disconnected from the main body of the house. This separation was enforced by city codes and insurance companies as the early car was too temperamental and dangerous to sleep next to. These diagrams of garage designs show ways in which the car could be kept close to and yet separated from the home.

In 1880, 75 percent of Americans lived in rural areas; cut off from city centers, they were disconnected islands of communities. Industrialism changed this, and with it, these local autonomies began their metropolitan migration in search of waged labor. But these densely populated areas lacked the architectural typologies the newly moved were accustomed to, and they were forced into shared apartments. It didn't take long for them to notice how large an impact this change in residence would have on both the structure and the quality of their daily lives.

The mutually cultivating relationship between man and land that played such a dominate role in rural life was gone, and feeling this drastic disconnect, these newly urban residents longed for an existence that would merge their new and old *byt*, city and country life, and quell the repercussive anxiety of industrialism that Odo Cheriton captured when he said, "I'd rather gnaw a bean than be gnawed by continual fear." They wanted urban opulence with rural security, the financial benefits of city life with the peace and quiet of farm life. The solution came in the form of the automobile, an invention that, in its cultural incorporation, would come to change the structure of society in just about every way imaginable, by providing the possibility of creating a significant distance between home and work, refuge and bustling city, not the least of which was its indelible impact on the formation of American suburbia.

On a fundamental level, the car restructured the relationship between space and time. But it also entered our cultural consciousness in a much more proximate way; our relationship with cars became so intimate that they were treated like pets, humanized, given a name and room in our homes. The influence of power this machine had on the rituals of life imbued it with a soul, and the ghost in the machine was created. The machine was not invented to have autonomy; rather it was a piece of metal under our control, feeding back into the psyche of patriarchal capitalism, in which the ego is exerted into everything and everyone around you, forming a ventriloquist-dummy dichotomy, in essence the dream of suburban reproduction was embodied in the car-human relationship. The car became the favored family pet, exploited and cared for by all. In creating a space in our culture for cars, however, cars and their manufacturers ended up influencing elements of our culture. This seemingly spontaneous glorification of the car is attached to a dark history of corporate interests and national economic reinvigoration schemes seeping into the home. Endemically, as if a parasite, the business of car manufacturing ruled and began to dictate existence; each garage built marked the successful adherence of the technology into everyday life.

With the advent of the car, the domestic realm was changed. This technology allowed for the house to be disconnected from its surroundings. The home was no longer attached to the land; rather, because of the car's needs, it was built around an infinite grid of streets and highways. The smooth paved roads allowed for an expansion of life, bringing commerce and food to previously dead areas; the areas outside of cities flourished with the new blood, ushering in the dawn of suburbia. Food was no longer grown on the family's plot of land but rather was bought, shipped from around the country, with seeds altered, grown in greenhouses, and

transported. The car was like a cargo ship that transformed the disconnected and quaint harbor into a trading center.

The domestication of the garage refers to the process by which the car and the room that held it became necessities in America's existence. The car offered a form of automated autonomy, a new kind of consumptive individualism. At the same time that the car made its way into the home, so too did television introduce moving images and media, allowing the family to consume in new ways. The home was liberated from its previous productive functions: food, clothes, education, healthcare, and entertainment became positioned strategically between home and car. Walking became unnecessary, almost a burden. This new vernacular held a promise of domestic bliss in which leisure became a form of gas-guzzling consumption. Suddenly, the space of refuge and rest was connected to an infrastructure of roads and highways that displaced domestic functions outside the home, morphing the house into little more than a dormitory. This restructuring placed the importance within a family on the organizations that they belonged to, the office they worked at, the country clubs they attended, the car they drove, and the clothes they wore. It was a corporatization of the suburb and its inhabitants.

(FOLLOWING SPREAD)

Untitled (red light on worker) by Luis Ortega Govela.

America saw in the car a technology that could and would support the speculation of land value and development beyond the urban center and a much more connected populous through the invention of a national infrastructure of highways and roads. The garage is an invention of an industrial society ruled by Fordism, and the spread of this typology was the beginning of the modern suburban construct. The intertwined histories of the garage and suburbia were written by legislators through economic pressure on the national government during the first financial crises of the twentieth century.

Following the economic decline on Black Tuesday in 1929, cities began to fill up with the unemployed, and families who were limited to one job per household re-relegated women back into the domestic sphere. Without jobs, the housing market also went into crisis, and with the closure of banks, homeownership trailed behind. Without a house in which to reproduce, the national birth rate, which shed light on the future of the country's labor force, came tumbling down. The domino effect of destruction, in which financial institutions first destroy themselves, then each other, and eventually the consumer, was set in motion, and the Roosevelt administration, in an attempt at prevention, began to strike a New Deal.

Home construction became the antidote for crises through the creation of the Federal Housing Administration in the National Housing Act of 1934. Keller Easterling, in her book *Call It Home*, describes the FHA as the legal transformation of "houses into a kind of currency." During the Great Depression, the house connected two areas in distress: employment and banks. To incentivize home construction, the FHA created the low-interest long-term mortgage as a way to reinvigorate the American construction industry and to provide new jobs. Stimulating the moderate-cost private-housing market, the mortgage proliferated homeownership, but it also

meant that you could own a house without having to pay in full for it, which created a debt system in which ownership was an illusion attached to increasing interest rates.

Inasmuch as the car provided new connections between the family and the outside world, the automobile offered a different mode of transport whose infrastructure had yet to be built. Floating, suspended in metal and plastic, burning oil over roads and streets, the car needed a circulatory system to move across the landscape. As the FHA was releasing the first mortgages Washington began to pump money into infrastructure projects that would further help to prop up the economy. While the car was undoubtedly a great tool there existed proposals for modes of transport that would bend toward the multitude rather than the individual. Electric streetcars and utopic visions of high-speed trains could have connected America, but instead car manufacturers strongly lobbied for the construction of highways, further reinforcing the concept of self-reliance and solidifying the car as the sole mode of transport, while at the same time providing the automotive industry with a clientele that constantly needed their product.

(FOLLOWING SPREAD)

Ford's Model T was released in 1908 and was the first mass-manufactured car. Decreasing production costs made it possible to popularize the new machine. Car manufacturers, Ford among them, lobbied for the infrastructure necessary to operate a car in an increasingly privatized America, manipulating the development and spread of a highway system. Collage by Luis Ortega Govela.

In coalition with car manufacturers, a great deal of propaganda was released by the FHA against the urban row house. Targeting the squalor of the city and exacerbating the problems inherent in metropolitan living, it promoted the suburbanization of the American territory. But the promise of suburbanization came with densely packed fine print. First, the institution would finance only single-family detached homes in peripheral areas, for these were seen as more secure investments. Second, if the house didn't come with a garage it would not be able to get a mortgage. Thirdly, the homeowner had to be white.

The suburbs were a white-washed profit-driven endeavor, a state-sponsored sprawl created to incentivize economies that were destabilized during the Great Depression. The safety that suburbia produced was cultivated to further property speculation and keep the wealth among the few and predominantly paler skinned. Carefully protected by covenants and zoning laws, suburban expansion zones were deliberately resistant to change; they operated like farmland, with humans as seedlings, cultivating subplot developments to increase value. What began as monocultural societies founded on racist practices turned into cultural and ideological deserts, devoid of diversity. Life became so monotonous it seemed dead.

The density of urban life may have found its overflow in the suburbs but this catch basin never caught the polyphony that presented itself in urban spaces. Suburbia was a response to the Great Migration of the former slave populations from Southern to Northern states. This movement began in hopes of finding new opportunity and as a means to escape a landscape embedded with persecution and oppression. The Northern states promised equality and work, and between 1910 and the 1930s the area above the Mason-Dixon line witnessed a drastic shift in the race of

laborers. The Italian and Irish populations that were previously relegated to the lowest faction of the workforce now had competition.

As many major cities felt the increase of a freed black workforce *white flight* began. This was the movement of white people out of the city and into the surrounding areas. The Jim Crow era masked its prejudice through an experiment in architectural eugenics that denied housing rights to people of color. The use of racially exclusive deeds became such a common practice across the United States that it was validated in 1926 by the Supreme Court.

After the New Deal, the federal government took a red pen to the map of the metropolitan areas of the United States, marking the areas that were "unsafe" for mortgages. This process known as "redlining" became the norm. It wouldn't take long to notice that it was only African American neighborhoods that were inked up, arbitrarily deemed too risky to provide assistance to. Without any way to quantify or justify these demarcations, prejudice became the calculator for risk.

(FOLLOWING SPREAD)

Picture from Bill Owens's *Suburbia* superimposed with åyr's *Cease and Desist*, 2015. White Sage from Topanga Canyon, Rick Owen nitrate bronze ashtray, burnt cease and desist letter from Airbnb, cigarette butts.

(PAGE 67)

Two oversized snake tongue sculptures entitled *Slow Violence*, by Olivia Erlanger. The sculpture addresses the cyclicality of capitalism. The tongues are a reference to the ouroboros, a symbol dating as far back as Egyptian iconography, which depicts a serpent eating its own tail.

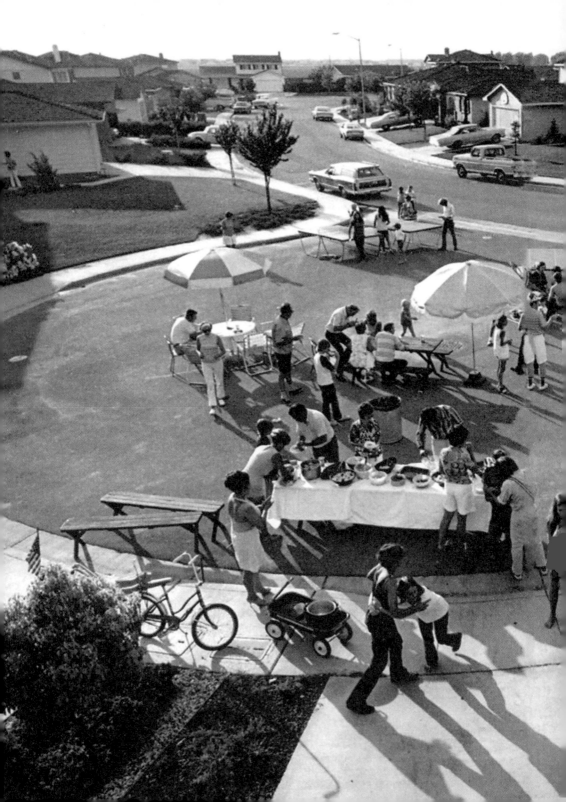

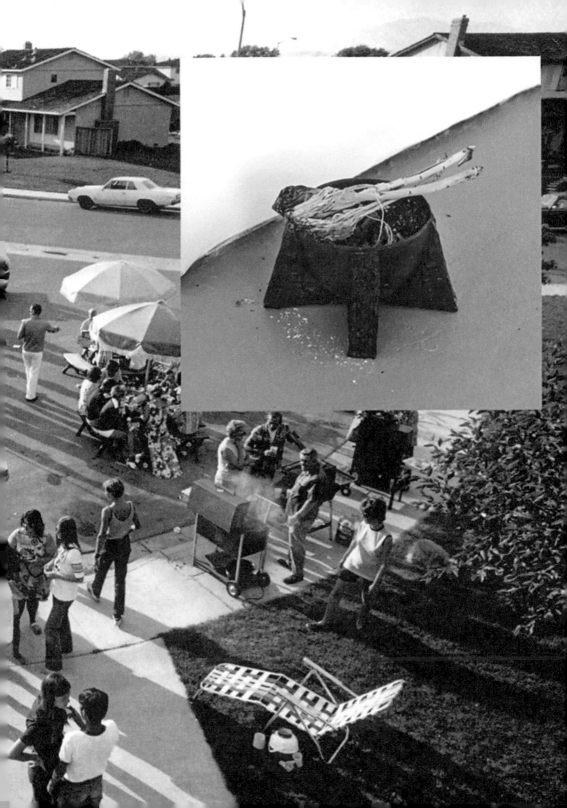

Although the deed covenants were found unenforceable by *Shelley vs. Kramer* in the late 1940s, structural racism was already bleeding at the core of the American suburb. Discrimination and segregation were embedded in the foundation of suburbia as single-unit housing developments spread, with new developments like Levittown, a colony of 17,000 homes open to rent in 1956. The funding for the construction came from the FHA, and it carried the condition that no homes be sold to African Americans.

Even though suburban enclaves had existed before, the introduction of the garage created a new suburbia. A purely residential zone neither urban nor rural, it was the land of an American dream, that of the individual homeowner. This new residential landscape aided by the car presented an antiurban strategy that denied industry, commerce, ethnic diversity, and the intermingling of social classes within the residential domestic environment. The more neutral, homogenized, and quantifiable the suburb and its inhabitants, the safer the investment. The suburb was designed for a white middle class, yet the whiteness contained within, rendered so perfectly, became a totalizing force in a global imagination. The imperialist power of suburbia became a global aspiration that acts as force of social control, by imposing gendered roles, racist practices, and general aggression toward the other, even if it is an internalized other. All these efforts made whiteness into the pinnacle of every hierarchy.

This domestic enclave became the smallest unit of the nation. The garage as much as the suburb was the symbol of white heterosexuality. Children were going off to school and getting high in parking lots, patriarchs were going to the office and finding solace in work, and mothers were somehow still tied to the house contemplating what, if not their own head, would be best cooked in the oven. The family was together but no longer at home. The separation between the place of work and the home was a gradual transformation of a patriarchal economy.

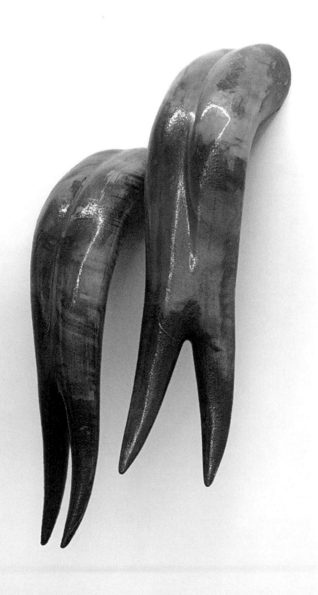

The domestication of the garage reveals the home in its process of financialization, as the space of the virtual encounter between the habitual and global economic forces. In the garage and the home, there is no longer a clear division between the personal space of domesticity and the immateriality of the financial. Through its economic value, the home reveals that it was transformed from a space of refuge to our primary financial asset. It acted as a testing ground for corporate interests. The explicit collision between the domestic sphere and the marketplace found in the garage reveals the conditions through which we exist today: human capital living in commodities.

# BIRTH OF THE
# ENTREPRENEURIAL **GARAGE**

The Federal Housing Administration, in its attempt to create a carefully protected residential zone, argued against the productive household, as, in their consideration, this would undermine social stability and reduce the financial value of the dwelling. These homes, financed by mortgages, were constructed for one purpose only: to house families; any other functions intended for these structures were prohibited. Suburbs became dry zones, focused on nonmonetary economies, such as housework and childcare; thus money had to be made outside the boundaries of its streets. Yet at the same time that the FHA created laws and zoning regulations that prevented the home from being used for production, it also prescribed that every home constructed have an attached garage, given that the value of the household would also be significantly higher with the addition of a safe space to store the car. Deeming domestic labor as something that fell outside of capital production, the FHA had no foresight that it was through the enforcement of the attached garage that the carefully protected suburban investments would radically change into incubators for industrialized labor.

The mythology of the garage as a space for invention started in a valley where taxpayers' money was being converted into silicon. Even though much has been said about Silicon Valley emerging from the shared geographies of Stanford and venture capital, its real history stems from military

research during WWII funded by public money. The garage is central to the origin of many corporate success stories in the twentieth century, from chauffeur to entrepreneur; the space originally intended for the storage of automobiles has become a symbol, a myth, a banal object in the domestic landscape that gave birth to the industrial tech complex. As the story goes, Walt Disney, Google, and Amazon were founded in suburban California garages. Here the garage can be seen as a monument to the creation of new labor subjectivities. It had become a cultural marker exposing the displacement of domestic feelings attached to the home, toward contemporary modes of production. Taking the Silicon Valley garage as a symbol that reminds us of the short-lived separation between life and work, we can trace back the shifts in the biopolitical space of the family and its effects on labor-power.

In the suburban streets of Palo Alto there stands a one-car garage, a converted shed that continues the ranch style of the main home but remains detached. It is a trite structure with a padlocked green double door. An embossed plaque on the front reads: The Birthplace of Silicon Valley. This garage is the birthplace of the world's first high-technology region, "Silicon Valley." The idea for such a region originated with Dr. Frederick Terman, a Stanford University Professor who encouraged his students to start up their own electronics companies in the area instead of joining established firms in the east. The first two students to follow his advice were William R. Hewlett and David Packard, who in 1938 began developing their first product, an audio oscillator, in this garage. The embossed plaque indicates its inclusion in the National Register of Historic Places. Such plaques usually decorate the facade of buildings of great architectural significance and beauty, structures that defied expectations and the potential of their time. In this case, the garage has been monumentalized for its economic and creative significance

rather than its subpar pitched roof and musky timber frame. The Hewlett-Packard garage became an icon, brought to light again in the late 1990s when a company best known for its printer technologies rebranded itself as HP. The advertising campaign INVENT was instigated by its new CEO, Carly Fiorina. With a new name and look, it was an attempt to make the company relevant again by linking it to its radical past. Fiorina hired the advertising firm Goodby Silverstein & Partners to help update the nearly irrelevant office-supply manufacturer and rebrand it as a tech startup giant. To do so, GS&P returned to the garage. Whereas Apple had capitalized on its relationship to the space and its punk attitudes, Hewlett-Packard had gone corporate. It was only after Steve Jobs appropriated that narrative for Apple that the garage became cool again, and it was retroactively imposed by HP as its own.

The campaign was powerful. It featured an image of the original HP shed, with a bright light shining through the closed doors and text superimposed that outlined the Rules of the Garage:

Believe you can change the world.
Work quickly, keep the tools unlocked, work whenever.
Know when to work alone and when to work together.
Share—tools, ideas. Trust your colleagues.
No politics. No bureaucracy. (These are ridiculous in a garage.)
The customer defines a job well done.
Radical ideas are not bad ideas.
Invent different ways of working.
Make a contribution every day.
If it doesn't contribute, it doesn't leave the garage.
Believe that together we can do anything. Invent.

When Carly Fiorina was elected as HP's first CEO she broke through the proverbial glass ceiling. But in the age of systemic misogyny she had to take a great deal of shit as CEO there. Infamously, she led the company into multiple failed merges and, at one point, was caught selling to the

Iranians while they were under sanctions by the United States. Fiorina kept putting HP through every possible loophole, as scrutiny around her tenure tightened the threads around her neck. HP was never able to be as hip or cool as Apple; it remained in Apple's shadow as it launched wannabe versions of personal laptops and music devices similar but inferior to the iPod. Although it never inspired a cult-like following, Fiorina and GS&P's team did succeed at reinventing the image of HP. Going back to the garage the brand became more attainable. Going back to the garage, the brand became sexy.

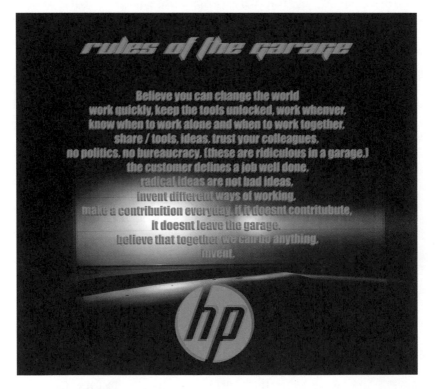

Rules of the Garage by Luis Ortega Govela . Original HP Invent Campaign copy, in Planet Kosmos font used by Kanye West (who shares a birthday with Frank Lloyd Wright) for his Calabasas Adidas collection.

The contested origin story of Hewlett and Packard's shed as their laboratory begins with Walt Disney, another garage-preneur, in this case seeking to create "moving sound," a prototype of what is now known as surround sound. As the story goes, Walt approached David and William, who were developing their first successful technology, the audio oscillator. The HP audio oscillators facilitated the immersive screenic experience by enabling surround sound, which became integral to Disney's films.

These little machines were made with the help of HP's first "employee," Lucile, David Packard's wife, who offered up her oven for baking the paint on the oscillator panels instead of making roast beef. Lucile claims her cooking never tasted the same again, but after their early success with the oscillators, HP expanded out of the garage and her oven, as they developed technology instigated by new defense contract work during World War II.

(FOLLOWING SPREAD)

A suburban garage collaged with sketch of a Joseph Eichler development and a photo of the interior of the Guggenheim originally designed by Frank Lloyd Wright as a pink concrete car viewing platform.

During the draft, Hewlett left HP to serve and let Packard steer the company as it took on government contracts. Aiding and supporting the U.S. military was important to both men. In fact, they priced the audio oscillator at $54.40 to reference the American expansionist motto from the 1840s to claim the Oregon Territory from the British, "Fifty Four Forty or Fight!" The collaborators were proud Americans, and later in his life, Packard served in the Nixon Administration as deputy secretary of defense, reforming the Pentagon's bureaucracy. Packard was nominated to this position because of the unique management strategy and innovative infrastructure he and Hewlett created in their offices. After the war the company had nearly 200 employees, but they faced severe cash-flow issues after the contracts' terms ended and they endured what both Hewlett and Packard referred to as the hardest years of the company. As they scaled back down to only 80 employees by the mid-1950s they created a more flexible and higher-quality working environment by offering profit-sharing systems, generous benefits, and more autonomy.

This production model was an ideology that made a lasting impression on both Steve Wozniak and Steve Jobs during their time interning at HP in the mid-1970s. Wozniak and Jobs were loyal to Hewlett-Packard and in some ways were raised within the company itself. Jobs first began interning there at the age of twelve. They were so loyal, in fact, that Woz even offered his designs for a personal computer to the company, which they declined five times before he and Jobs left to start Apple. Emulating and operating within a paradigm HP had created, Steve and Steve mobilized, and they created their corporation within the framework of a garage start-up, perpetuating the garage myth even further. Additionally, the open management style of Hewlett-Packard has percolated throughout the Apple ethos and within its office life.

Frank Gehry's Walt Disney Concert Hall as background to a Peter Pan cutout and a
Mickey Mouse–hand pin by Olivia Erlanger

The startup garage has become more than just a part of Silicon Valley's folklore; it has transformed into an image, an exportable idea that reveals a set of strategies and theorems that continue to operate in post-Fordist immaterial modes of production and consumption. Its history reveals that mythmaking has become as central to sustaining our economy as profit making. The garage became the architectural symbol that would attract the right venture capital. Once the garage is dematerialized and mobilized by the characters, corporations, and technologies that emerged from the space, it becomes a doctrine stretching its existence beyond the private and intimate format of the house and goes on to reabsorb the public.

# GARAGEIFICATION OF **SPACE**

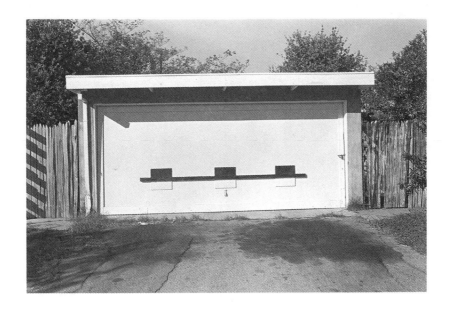

In the previous chapters we elaborated on the ways that the suburb was constructed as a whitewashed zone that would allow for only the procreation of the human species and the basis upon which a myth of the perfect American family could be created. Inasmuch as the attached garage is in itself a central piece of infrastructure behind the rapid decentralization of the urban core and a symbol of the auto-dependent residential periphery, it is also within the garage that the suburbanite came to contest and protest the purpose of the suburban zone that they came to call home. To understand how at the end of the twentieth century home and work started mirroring each other both in their aesthetics and in their biopolitics, we must first define a new concept, the *garageification of space*, the symbiotic process by which home and work cross-fertilize. This is a dual operation in which the space of the home is colonized by production, and in turn production and its spaces are domesticated by the attitudes present in the garage. Once home and work are garageified there is an erosion between the domestic and productive spheres, where the dichotomy, language, and aesthetic of home and work borrow from one another. Refuge becomes a symbol and a delusional state of mind.

*Garageification* refers to the process by which a society appropriated leftover industrial spaces as a means to define a new modus operandi, one that defied the system from which it originated. But it also points toward

a larger symbiotic condition in which home and work entangle, blurring the lines between industrial and residential space. Within this, the suburban image became a false one; the promise of the family under the conspicuous and judgmental gaze of neighbors instilled a desire for escape by its inhabitant—the suburbanite—and the only space provided for this to happen was the garage.

The garage presents itself as a blank canvas. This tabula rasa speaks of the possibility and potential for authenticity, rather than stagnant constraint provided by the home. Easy to hide inside, the garage was the only liberating space in the domestic landscape. Perfect solitude was attainable within its walls, allowing for a greater freedom in which a departure from domestic rules could be reached. The space came to justify its post-functional presence in the household through the creation of this culture of freedom, one that glorifies individuality. The entrepreneur, the punk, the teenager make themselves by making a place for themselves. The rough concrete—opposed to the soft furnishings and wallpapered walls of the interior—mixed with the open plan allows them to create worlds in a risk-free environment; the space of refuge is just one click away. If the hearth is the heart of the home where the family gathers and reaffirms its structure, the garage becomes the space where the individual's full identity can develop. It allows a degree of separation from the familial construct and embraces a world of capital production. Production thus successfully trespasses the home and the domestic and establishes itself as a refuge from the institution of the family. As a result, the garage affirms, confuses, and destabilizes the domestic sphere. Examining the history of how the garages in the Bay Area came to be allows us to understand the psychologies imprisoned by these Bay Area suburban structures as the ones that have created the technologies by which we extend outside of our isolation,

creating new paradigms that are continuously shaping the city and its subjects.

Silicon Valley was founded on the commodification of the home that was further encouraged by legislation passed in the postwar climate. The G.I. Bill from 1944 helped (white) soldiers coming back from fighting in WWII take out mortgages to finance their homes; developers took note of this and saw an opportunity in backing suburbia. Home ownership became not only synonymous with the American Dream but also with reward: bleed for your country and your country will give you shelter. As the 1940s leaned into the 1950s, the myth of the nuclear family, in all of its simplicity and heteronormativity, was glorified and pop-culturized through TV shows like *Leave It to Beaver* and *Father Knows Best*. These shows epitomized the banalities of belonging that the suburb depicted. They were one long weekly ad that passively screamed: If you lived here you would be home by now.

(FOLLOWING SPREAD)

A raft sculpture by Olivia Erlanger, *Raft for the Doll in Glass*; bad boy car headrest assembled at Rupert by Luis Ortega Govela and Olivia Erlanger; glass espresso machine rendered by åyr.

At the same time a small movement of poets and artists was drawing itself in a new light. Calling themselves the Beats, they stood against the overbearing confines of the normative enclaves and standardized behaviors of the 1950s. A metaphorical vehicle for creative movement, the car became the Beats' instrument for revolution; they hacked into it to produce a new punk alternative that denied the sedentary life that came attached to the suburban ideology of home ownership. Jack Keraouc's *On the Road* tells the story of Neal Cassady and the authors' rebellious journeys across America in search of an alternative lifestyle. Through the Great American Road Trip they lived nomadically, happy only when in transit, as a way to reject the potted lives most everyone else seemed to be living. The Beats, as they searched for an alternative, became the alternative. Their radical thinking, their radical music, their drugs, their Kool-Aid, went on to influence the next generation of innovators, taking the car out of the garage and into unknown landscapes.

The 1960s were the golden age of the suburb and the nadir for many urban areas around the United States, not to mention a boom time for highway construction and the development of low-density residential zones on nongridded street patterns. The suburbs were spreading quickly, and with that Wright's Prairie ideals began to infiltrate the everyday American home. The Prairie was a an architectural reflection of Wright's own projections of a patriarchal familial ideal, one that he could not manage to participate in but that he romanticized in his designs. During the 1970s and 1980s large swathes of these subplot developments were being built in America. The resulting separation of Wright's family after living in the Prairie resonates with the fracture of the American family. In this golden age of the suburb divorce rates crashed through the pitched roof, defying

the idealized image of suburbia and the institution of matrimonial harmony.

The suburbs presented a new context for collective life, in which families were living next to each other; this false sense of community was the unstable foundation for the suburb as it championed the individual rather than the commons. There were no shared properties or front lawns in suburbia; everything was subdivided and demarcated with a name. These zones emphasized the original philosophy behind Wright's work: Emersonian self-reliance. The suburbs were built for that, staking out personal property with hedges and pickets. Producing a culture of ownership, it was the invasion of the body snatchers, pod people invested in themselves, rather than the communal life that the image of the suburb so wanted to present. You were a homeowner in the land of the free but shackled to a mortgage, a place, and a familial role.

In the 1960s the youth of San Francisco and the Bay Area manifested their discontent toward traditional codes of behavior through their sexuality. It was a countercultural movement in which sex occurred outside of traditional monogamous relationships and the invention of the contraceptive pill, public nudity, porn, and queer dialogues became the tools by which adolescents rebelled against the history that produced them. Bodies against bodies, orgies, and the dawning of the Age of Aquarius are the predecessors of the idea of a utopic connectivity resulting from a networked society. The assumed alternatives to the nuclear family that would be produced from these new coexistences laid the foundation for the idea of a World Wide Web, displacing the suburban myth of the perfect American family. This was a youth that wasn't going to fight the war or join its corporations. They were radical individuals and they were taking ahold of American consciousness.

Here, the garage gets dropped in acid and turned inside out. By the 1960s and 1970s, and for youths like Steve Jobs and Steve Wozniak, it became the space in which they could bend their realities and in which they would end up creating technology that would bend the world's. The garage's legacy as a paradigm with the capacity to restructure society was yet again established with the alleged creation of the first desktop computer within its walls. The myth is pervasive; essentially it goes that Steve Wozniak, a Grateful Dead–loving, hippie-nerd, geek wizard, toyed long enough in his garage to birth the first personal computer. And it's a myth that by and large his ashram-dwelling best friend and soon to be business partner, Steve Jobs, went on to seize as his own.

Steve Jobs—just like Wright—was a character so preoccupied with his own mythology that his personal history was severed in two: the real and the doctored, the truth and the supertruth. The image of his persona is as real, or maybe even more real, than its fact, for it was through his distorted reality that he created Apple, a company that went on to produce the tools that made the home and workplace fit into our back pockets, that, in a sense, garageified our existence. If the garage points toward the rise of the human-car cyborg, Jobs created the body augmented by the smartphone. No longer limited to a physical geo-location, the new geometry of identity is a triangulation between an individuated experience, an "outside" world, and within the sharing screens of iPhones. The most interesting aspect of the garage is not that it has created revolution but ultimately that it is always attached to the traditional values of a suburban home; the radical inventions that happened within it are still reinforcing the patriarchal capitalism and gendered domesticity from which it emerged. The infinite grid of connections and possibilities that the early internet

proposed has come with its limitations. The multiplicity self-constructed within the home of suburbia has expanded to the web where it remains a social fiction that is still understood and rooted in physicality.

An inversion of the traditional matcha latte with heart
foam art by Luis Ortega Govela.

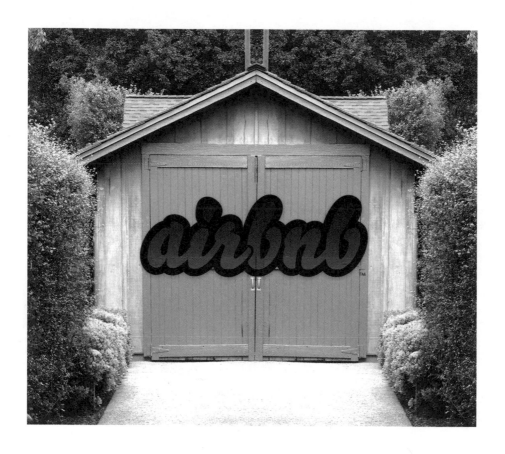

Mirrored HP garage with original Airbnb logo by Luis Ortega Govela.

Garageification by Luis Ortega Govela. Line drawing based on Diana Walker's photograph of Steve Jobs in his living room published in an 1982 issue of *Time* magazine.

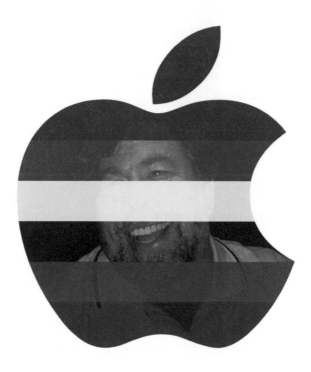

iWoz by Luis Ortega Govela. Apple logo with pride
colors and a portrait of Steve Wozniak.

Sculpture, *Sideways Time*, by Olivia Erlanger. The sculptures, office-like filing cabinets meant to preserve both private information and public records, are partially cut out to expose their components. The light is programmed to adjust according to the price of oil variations.

Steve Wozniak—who actually built the first personal computer but who was overshadowed by Jobs's charisma, uniqueness, nerve, and talent—published *iWoz*, an autobiography exposing the lie behind the Apple garage. In it the computer geek turned cult icon claims that the garage was never used to design, plan, or manufacture any of the early products. Regardless of his charming book title it is Jobs's romanticized and poetically constructed notion of the garage that continues to exist in the cultural consciousness; it is present in the two films based on him and in his biography (which has become the most-read book in China), and it has saturated pop culture. Regardless of Wozniak's factual account, it is Jobs's magical and false reality that is known as truth. As it percolated and reverberated, it spread across the surrounding Bay Area.

The banalities of the garage have reached a status equivalent to mythological symbol. Jobs and Wozniak first made the space famous through the combination of their purported average, humble beginnings and their ability to create prescient technologies for a not-so-distant future. Fiorina and Goodby Silverstein capitalized on the power of this story to aid the HP brand in its transition into the twenty-first century and out of the dot-com bubble. Over the course of the two companies' reign over Silicon Valley, the garage became associated with the displacement of "labor," an ideology that sits between work and domesticity. The garage has become the institutionalized space for the reinvention of the white middle-class self toward the production of wealth, a space for venture capital that pretends to dismantle the status quo but in actuality profits from it. This sort of use of the garage serves only to perpetuate an apolitical occupation of space that is deliberately hidden and camouflaged. Stripped of its power, the garage is exploded and expanded to encapsulate the whole city by colonizing the house

and the tech office. The idealistic and illusory image of the garage rematerializes no longer as a space defined by four walls but as one dependent on devices that augment our existence.

Now work is located somewhere between home and office. This refusal to settle has been incorporated into contemporary office land- scapes. This is the garageification of space, the ability to project into any space a productive framework that facilitates both creation and consumption. It is an all-encompassing domestic comfort within which we naively exist. Think of the co-working space, the Googleplex, or the organic café; each is constructed as a quasi-domestic space where the comforting atmosphere of bean bags and adult playgrounds exists to infantilize and induce an efficiency of production. It's the entrepre- neurial ethos of work disguised as leisure. In a hyper-individualized workforce, the original "HP way" has been further abstracted, allowing for freelance work and a kind of pervasively casual professional to emerge. The twenty-first-century worker awakes in the morning in a bed office slowly moving to working at a desk in an apartment studio to an international Skype call from their Lyft to a meeting in a nearby coffee shop. Garageification is not only a way of transforming any physical space to better suit one's needs; it also shifts across technologi- cal platforms to allow laborers a sense of seamlessness, fluidity, and ease as they produce data and increase their capital. It is frictionless capitalism.

The garageification of space is epitomized by the suburbanite who escapes the confines of the suburb, but in that process looks for the same comforts of home, whitewashing their way to their almond milk latte, creating a suburban bubble in the urban environment that pushes out anything that doesn't suit their needs or that stands out from uniformity.

These spaces present themselves with a fake patina of history; it is the reclaimed happiness of a society in postindustrial decline. They are the gentrified zones, young, fresh, thriving, eclectic, hip, authentic, local, multicultural, colorful, pretty, bustling, vibrant, new, independent, hidden, liberal, pressed, organic, and up-and coming. The bare pipes and wiring, the rough concrete next to the exposed brick, and the plywood furniture are a suburban wet dream of the industrial aesthetics that were missing from their childhood. The people, culture, and colors that were extensively kept out of suburbia are appropriated and transplanted as a sign of worldliness: a Mexican poncho hung on the wall, a Chilean rug, a table made in China on top of which an Ikea bowl sits, filled with blood-quinoa, all ordered through Amazon Prime, a company that started in a garage. This is the symbol of our global times, all to be priced out later on by some Russian oligarch interested in investing in the area. Garageification raises questions about the existence of the local and authentic within globalized production patterns. Is it a form of resistance or is it a form of violence? Maybe it's all just a Faustian bargain and a form of self-sabotage.

APPLE **GARAGE**

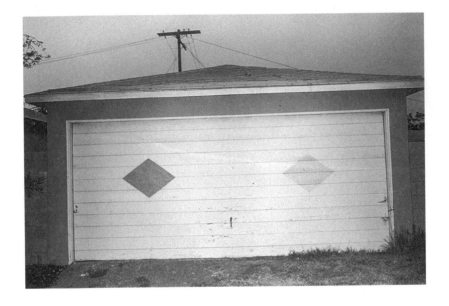

In Walter Isaacson's biography, Steve Jobs recounts his early years spent in his Mountainview garage with Paul, his adoptive dad. Paul was a tattooed mechanic, and if Jobs wanted to spend time with him he would do it by tinkering in the garage. Surrounded by his father's collection of framed photographs of dream cars, as he worked alongside his dad he developed an interest in electronics. Paul would fix cars to make extra money for Steve's college fund, so when they moved into the El Diablo house in 1969, Paul decided to get a house with an exceptionally large garage. The bigger the garage the more profit could be milked out of it. His predictions went far beyond his expectations when, seven years later, Jobs and his then best friend turned frenemy Steve Wozniak would plaster the walls of the Mountainview garage with the sketches for the first pre-assembled personal computer. Behind that automatic door a company was forming, one that would go on to be known as Apple. During Jobs's time interning at Hewlett-Packard when he was a teenager, he claims to have learned the "blueprint" after which he modeled his own start-up. Jobs took the HP formula and the garage origin story and created a revolution.

Until his death Jobs believed that he had grown up in an Eichler house and Isaacson took Jobs's word for it, including it as part of his definitive history, successfully propagating what is an alternative fact and supporting its reality in the cultural imagination. This is another example of Jobs's

many fictionalized renderings of reality. Unlike the Wozniaks, who had actually lived in an Eichler home, the Jobses' house was an imitation, a *Leichler*. It was probably Wozniak's interpretation of his home that Jobs claimed as his own when describing his house when he was a teenager. "Eichler did a great thing," Jobs told Isaacson on one of their walks around the neighborhood. "His houses were smart cheap and good. They brought clean design and simple taste to lower-income people." It was in this house that Jobs first encountered an aesthetic that was modern and sleek and was not rooted in nostalgia. "It was the original vision for Apple. That's what we tried to do with the first Mac. That's what we did with the iPod." Regardless of whether it was an Eichler home, the El Diablo house where Jobs spent his childhood was based on the same mid-century ideals that Eichler had used to build his subplot developments.

Eichler was a New York Jew living in San Francisco, working in the financial department of his in-laws' food distribution company. In 1943, during a midlife crisis when he was 50, Eichler left that job and moved into one of Wright's projects in Hillsborough, California, which he called *Usonian*—his term for homes he designed for a new, utopian suburban world, a vision for the future of America and the radical individual. Just as Jobs had been inspired by Eichler, Eichler developed a maniacal Wrightian obsession during the two years he lived in one of Wright's Usonian houses, the Bazett House. Eichler was so moved by the design that in 1945 he reinvented his career by buying a prefabricated-house construction company, bringing him one step closer toward Wright's Usonian dreams.

If the Prairie style was Wright's Macintosh, Usonia was the iPod, Wright's second foray into designing a truly American domestic

vernacular. Developed in the 1930s during the Great Depression and at the same time as he was finishing Falling Water, these houses were meant to be moderate-cost single-family homes. The Usonian movement had become known in intellectual circles in the Bay Area because of the Honeycomb House. The house was built on the grounds of Stanford University for two of its professors, the Hannahs. Their house was Wright's first structure that moved away from the Froebel rectangular geometry and into a hexagonal floor plan. It was a house without straight angles, and the Bay Area intelligentsia buying into the idea wanted more Usonian homes. The Hannahs prompted the Bazetts to send a telegram to the architect at Taliesin West, asking him for a home design without sharp lines. The Bazetts had a limited budget, so Wright offered them a Usonian house. To cut costs Wright employed the balloon frame, a traditional structural shell whose assembly of nailed studs was renowned for its simplicity. It was mockingly named after the party decoration known for its ability both to fly away and to burst.

(FOLLOWING SPREAD)

Aerial view of Joseph Eichler tract houses and the original Apple logo from 1976 as designed by cofounder Ronald Wayne. A wood-cut illustration of Isaac Newton underneath an apple hanging from a tree. Around the border the words "A Mind Forever Voyaging through Strange Seas of Thought --- Alone."

The balloon frame was light and portable and, most important, it enabled suburban homes to spread parasitically. Wright often encouraged his clients to get heavily involved with the building. All the balloon structure needed for it to be erected was two people (traditionally father and son). Wright, ever the inventor, realized that the traditional eighteenth-century balloon frame was a redundant structure, so for his Usonian homes he decreased the number of studs, allowing for bigger glazed openings and clerestories. These homes were a predecessor to IKEA furniture, in that the clients would get a catalog from which they could select the pieces and then assemble their home from Wright's manual like set of construction drawings.

The Usonian architectural model was a response to the paradigm shift in production occurring at the time; the displacement of work from the home created an emergent generation that led mobile lives. Wright, inspired by the Fordist line of production, intended for these houses to be built en masse. It was an inexpensive and adaptable typology developed for Wright's never-realized Broadacre City. The project was an idealization of suburbia, an egalitarian space designed to give each family exactly one acre of land on which to live. But Broadacre was just that, a dream, an impossible blueprint to follow, whereas the Usonia houses, built as one-off projects, slowly found their market. Wright built approximately forty of them, but the original intention of mass production was never realized. Wright soon lost interest in the project as he started working on bigger institutional commissions like the car-inspired ramped Guggenheim, leaving it to Eichler to build upon his Usonian legacy.

Eichler wasn't interested in building low-quality mini-mansions in order to turn a quick buck; rather, he wanted to bring modernism to the postwar Californian family. Eichler, a businessman, hired Robert Anshen,

an architect who was as obsessed as Eichler was with Wright, to design the tract homes. Anshen took advantage of the mass production techniques coming from the prefabricated company Eichler owned and designed the homes as boiled-down versions of Wright's Usonia. The duo built around 11,000 of them in the Bay Area. The Eichler homes didn't emulate Wright's hexagonal floor plan or its brick and timber frame facades, but they did keep some of its functional features: the glazed facade, the timber framed structure, the underfloor heating, its connection to nature and the outside, the open plan in which dining and living room were fluid spaces that would overlap. Most important, the homes retained the carport.

In Usonia, Wright got rid of the garage to save on construction costs; the expense of having to build an extra four walls could be better invested in another area of the home, one that wasn't designed to provide room for a machine. To resolve the need for a space for the car, Wright started incorporating the *carport*, a term he coined to describe a spatial elaboration of the *porte-cochere*, which was used in eighteenth-century France to allow entering carriages under weather protection. The carport was a simple roof structure without walls, usually located next to the main entrance

(FOLLOWING SPREAD)

Frank Lloyd Wright's Hanna House with honeycomb pattern.

door, making the exposed automobile the prominent feature of the front facade.

When Eichler and Anshen replicated the Usonian model on a large scale in the Bay Area, the homes kept both the garage and the carport. Building the structures next to each other was excessive. In Wright's mind the carport eliminated the need for the garage, but the two rooms were forced to coexist as a result of the postwar bureaucracy of mortgage requirements. People would not consider buying a house without an attached garage and banks wouldn't invest in a product that wouldn't sell. Regardless, it was through the introduction of the carport that the garage was liberated from its functional constraints and deprogrammed. The garage finally managed to cast off the car and became an empty room that a family could mold for their own use. The Jobses, alongside the Wozniaks and almost every other family in the area, would keep their car under the carport, and thus the garage, freed from the car, became a blank addendum.

The Eichler developments were a case of Broadacre City meets Bauhaus in the suburban cul-de-sac, and California was not ready for it. The genius of Eichler was to hire a marketing person; to be able to sell this modern vision for the home there needed to be an image attached that shifted people's aspirations. Eichler understood the power of image making. At the time the FHA would not finance homes that were not built in the ranch style. Modern designs were deemed too risky an investment; its symbol of progress had yet to catch on as one of domestic bliss. Eichler was forced to construct his own clientele. Photo shoots took place in the interiors of the homes, while Knoll furniture and white families revealed the magic of the open plan. Wives with pearls were photographed taking a dish out of the oven while keeping an eye on their

children who were playing on the shag carpet of the living room. The family seeing dad return from work through the glass facade would run to the main entrance next to the carport to receive the patriarch. It was beautiful propaganda for suburbia that directly propagated the desire of a new way of life and Eichler homes were ready to provide it. Modernism was not something people wanted, but with these images Eichler made them need it.

Just as Eichler had to build an image for people to make them want his product, so too did Jobs for Apple. In 1984, Apple introduced the Macintosh. The Mac was the company's first mass-market personal computer; at the time most consumers were unsure of the product's necessity within the home. That first computer sucked, but everyone remembers the ads. The clunky processor was released alongside a Super Bowl commercial directed by Ridley Scott and written by Scott Hayden. The video depicts a workforce of human drones in a factory. A lone female athlete runs through the center of the gray uniformed laborers, wielding a sledgehammer. Wearing a T-shirt with an Apple logo she approaches a projection of Big Brother; she throws the sledgehammer, shattering the screen. The message is clear: the old guard and its ideology, its computers, will enslave you, while the new will set you free, giving you access to tools for fighting conformity. Rather than depict a personal computer, something people were unfamiliar with, the marketing team redirected the imagery to the common and universal themes of marginalized subculture discovering agency, struggle leading to breakthrough, and the oppressed finding freedom through resistance. They depicted a hero making a divergent future possible, one who thinks differently and shatters the bureaucracy of the past. It was Jobs's own vision of himself, so much so that investors threatened to pull the ad from its

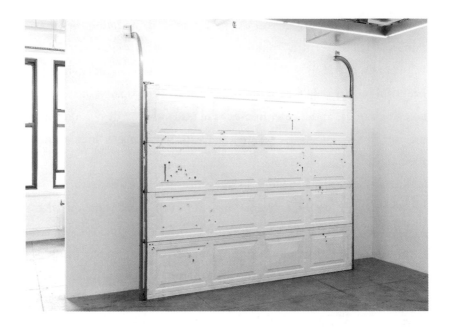

*Palimpsest* sculpture by Olivia Erlanger. When she showed this to her father he exclaimed: "This is the worst sculpture you've ever made."

Steve Jobs latex mask.

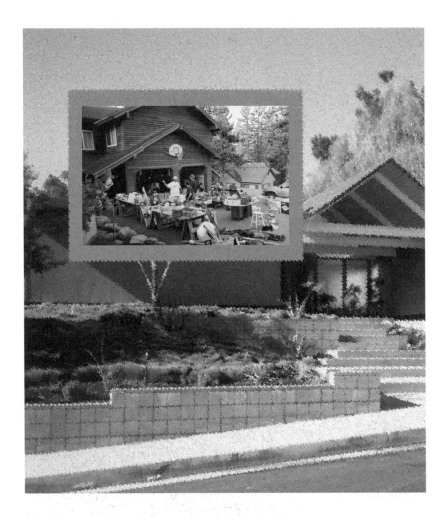

Yard sale superimposed onto a mosaicked Eichler, by Olivia Erlanger.

spot at the last minute. But Jobs pushed to get it on everyone's TV, establishing the myth.

The potential for radical action for deviation from the current system toward the construction of a new mainstream, as depicted in the ad, stemmed from the Hewlett-Packard and Apple foundational garage stories. To this day the narrative has become a blueprint employed by many tech start-ups, to the point that it has become a gimmick. "We started in a garage" is the equivalent of saying "we met on Tinder." Nonetheless, the uncanny liveliness of the mythology of the garage within the tech industry reinforces its own importance. It is the belief in the cliché that makes it real.

# REALITY **DISTORTION**

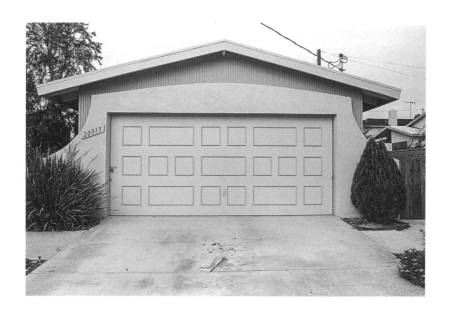

Abandoned, chosen, and special: if there is one connection between Jobs and Wright—beyond Joseph Eichler—it is their delusionality that turns lies into truth. The abandonment made both figures independent, being in a different world than the one that they were born into. But just as we have seen with Wright, he who is abandoned is often an abandoner. Later in life, at the same age as his own father had been when he was given up for adoption, Jobs refused to recognize his daughter. These two histories, one that took place at the beginning of the century and the other in the later half, expose a theme within our culture: the neglected task of fact checking. A story is all people need to create belief.

*Reality distortion field* is the term that Apple employees used to describe Jobs's ability to make anyone believe in his dream of a future not yet founded. Jobs was able to bend reality in such a way that it made an impossible task appear easy by indoctrinating the masses with his vision. The term came from the science fiction television show *Star Trek*. In a two-part episode, "The Menagerie," RDF was used to describe the ability aliens had to create a new world through mental force. Similarly, Jobs was able to control the output of his company by using charm to manipulate his team into realizing his vision. His disconnection from his material reality and context was so profound that he would also use RDF to appropriate another's ideas as his own, sometimes proposing an idea to its originator

after dismissing it the week before. In Jobs's dictatorial attitude, truth became subjective. According to Andy Hertzfeld, a software engineer who was part of the original Mac team, "The reality distortion field was a confounding mélange of a charismatic rhetorical style, indomitable will, and eagerness to bend any fact to fit the purpose at hand."

Reality distortion is just a clever way to speak about lies, madness cast as nonconformity. Jobs used his denial of reality to construct and believe his own vision and then spread it to everyone else. It was a self-fulfilling distortion rooted in objectivism, the movement based on the writings of Ayn Rand, who had been inspired by Frank Lloyd Wright, in which reality is consumed through perception, within which a moral purpose can be carved in the pursuit of an individual's own happiness. Like many Silicon Valley entrepreneurs of his time, Jobs found guidance in Rand's books *Atlas Shrugged* and *The Fountainhead* and her proposal for *rational individualism*, which advocates that people not be subordinate to any moral code or system other than one of their own making. It was a philosophical movement that celebrated the radical individual when it first appeared in the neoliberal landscape of identity.

What Rand was proposing was a transgression of traditional morality, a new value system in which selfishness is a virtue. She imbued her characters with the power to live life the way they want to. In *The Fountainhead* the Wrightian Howard Roarke destroys a construction based on the perversion of his original design. Destruction is here championed, as it prevents the original purpose and meaning behind the work from being subverted, in the *longue dureé* of maintaining purity and integrity. In a world oriented toward the production of profit, violence maximizes labor-power, so that destruction becomes a productive force. Wright and Jobs

epitomize this Randian hero; both created their own sets of rules and molded reality to fit their identities. This practice is at best perceived as the temple of the radical individual and at worst as the cult of the moral transgressor. In Freudian terms this can be described as social deviance rooted in the antagonism between freedom and the prison-like systems of control we inhabit, such as that of suburbia. In a Nietzschean sense it is a will to power. It is the conscious construction of a radical individual in which the way he sees things is the only and right way. It's a criticism of morality toward its self-involved perversion, a phallocratic ideology claiming one more victim, the pursuit of success inside patriarchal capitalism.

What Rand saw in Wright was an individual who valued self-reliance over collectivism, a character who valued independence and integrity more than conformity. During her short correspondence with Wright, Rand begged to meet him; she appealed to his ego by saying, "The story of human integrity is what you have lived. And to my knowledge, you are the only one among the men of this century who has lived it." She went all out to get his attention and this type of flattery typically would make Wright leap out of his chair; alas, he declined. Nevertheless, his idealism remained the template upon which Rand developed her objectivist philosophy. Both *The Fountainhead* and *Atlas Shrugged* reclaim selfishness as a positive, a fundamental code to follow in the search for personal happiness. Actualization in the process of seeking happiness means that one does not compromise or bend to the will of others. It is the story of one man against the system.

(FOLLOWING SPREAD)

Ayn Rand's passport photograph and Walt Disney logo.

The interweaving of the dropout culture inspired by *On the Road* and the human potential movement inspired by Ayn Rand began to define a new kind of consumptive individualism in which Jobs and Wozniak grew up. In this self-help climate of the late 1970s, seminars like Werner Erhard's est gave white-collar workers gathered in a hotel conference room the tools for reinventing and transforming behaviors that were said to be holding them back from their most productive selves. These talks were orchestrated to hack into the individuals psyche in an effort to better themselves and are eerily similar to Jobs's Apple product presentations. The search to redefine oneself shifted from being against participation in mass society, to being against one's own personal narrative, breaking through in order to better succeed within the parent culture. This was a strategy for reinvention, and the garage seemed to be the perfect stage for its coming out. By constantly reframing their pasts, they distorted reality, self-mythologizing and fabricating an entrepreneurial narrative. It was a capitalist self-transcendence that defied a limiting behavior.

Constructed upon a mechanic delirium force fed through consumerism and accumulation, the suburb presented an idea of unique sameness: live the same way as everyone else, wear the same clothes, but still retain your individuality. It was tied down to the ubiquitous social values of heteronormative love and traditional family structures. An easily exported image, it has become a symbol of America more than any skyscraper or tower has come to be. Through the suburban image an ideology was created. The way Americans lived made the rest of mankind stare with envy or disgust but always with awe. Yet its architecture was hollow. Suburbia became the most desirable place to live; through TV shows and advertisements, it became *the* taste. Mass culture reinforced the suburbs as the only way of life. The land of the free offered singular detached homes with a

minimal amount of personality to those who could afford it. The pitched roof, the roof shingle, the cheap framed structure, the picket fence, and lastly the garage, these were the inflexible symbols behind the American delusion, the palpable objects one had to stand on to be able to reach for their dreams.

The fabrications in both personal history and the projected fantasies of Wright and Jobs is mirrored in their distortion of the American Dream, which they bent history to become heroes of. And yet they also represent the inverse, the American delusion, the id to the superego of the dream, one that offers only the illusion of a freedom of choice. The cultural capitalism that both Apple and Wright's designs produced is seen in the global exportation of their brands. Wright's influence on European modernism arose through the *Wasmuth Portfolio* of 100 of his lithographs, but Apple remains distinctly involved in the distribution of Jobsian values and behaviors through their products. These two characters leveraged RDF to such an extent that their brands, while born in garages, are homogenizing local cultures and replacing them with their own prototypically American ideals.

(FOLLOWING SPREAD)

A 1978 Volkswagen Beetle, aerial views of suburbia, and the Tesla logo by Luis Ortega Govela.

Walt Disney sketched new universes in his garage for the world to enter. His animations were disseminated across media, in movie theaters and on television sets; Disney used entertainment to enlist people into his vision. Disney's, Wright's, and Jobs's creations traversed architectural draft, television screen, and computer desktop into physical spaces. Disney created immersive theme parks where children could touch and hold their favorites of his characters. Wright's designs sprawled into great suburban swathes, and Jobs's personal computer turned into a universal handheld device. The image they each constructed in turn produced landscapes to inhabit. For this reality distortion to take place they needed a space. For Wright it was his studio, which he called a playroom, which he would rearrange constantly to test out ideas. For Jobs and Disney it was the garage. Both spaces were unhindered by preconceptions of use; they were seemingly free zones of operation, but the occupier was still affected by the surrounding reality and context. They developed spaces from which they could construct themselves and in which lies would be reborn as truth. Confusion was systemized to help discredit the world of reality. Their image and personal narratives were the edifices upon which their constructions could take place. Each revised his history, deleting the version that had come prior and offering his as alternative. As self-destruction was key to invention, they incinerated their past. By revising history, they rewrote it toward technological *(r)evolution*.

In the garage, dreaming only in your sleep became lazy. Being everything that you were not was the aspiration. The garage became the reactionary space in which the occult pact between the future and the past was set against the present, in concert, and thus differentiating itself from progressivism (which unites the present and future against the past), and

conservatism (which unites past and present against the future). This renewal brought in more invention, more capital, and the promise of an ever-expanding dream to attain. Disney, Wright, and Jobs distorted and diverged reality, and they have become guides to emulate, offering a path to follow, existing as demigods who are still part of American folklore. They became proselytizers of the American Dream. In the mighty entre-preneurial pursuit of a techno-enlightened humankind, these are the risk-takers who raised the stakes.

(FOLLOWING SPREAD)

Ford production line and a balloon frame structure.

What is at stake in RDF is that fiction creates fact. Culture has moved past fact, in favor of audacious storytellers who reinforce elevated truths, with stories that create new paths of being, and higher dramas that invent new selves. Mythmaking in its Grecian and Roman sense is the same process by which a nation like America came to be, by obliterating its own native history. This tabula rasa of culture is based on the subsumption of a previous locality's identity to erect a new one. The Roman wolf that nurtured Romulus and Remus is Job's fabricated Eichler-house beginning. The old suburban dream is increasingly out of sync with today's culture, and when the individual homeowner is left to his own devices to redefine his existence, the process is one of self-destruction. One has to deconstruct the whole belief system of the American Dream time and time again, to emerge anew. By deprogramming the self from a moral code imposed by society the dream is allowed to expand beyond its previous confines. In this process the suburban home has become a caricature of itself. Ever expanding, it appears as if a Disneyfied vision of a larger-than-life home. Overscaled, the home appears to be confused as to what it is actually housing: objects, egos, or the human species.

(FACING PAGE)

Joseph Eichler house with the original Mac hello screen; floating above, Steve Jobs and his first daughter, Lisa. Allegedly Jobs refused to recognize her as his own until she was eight.

# DEPROGRAMMED **GARAGE**

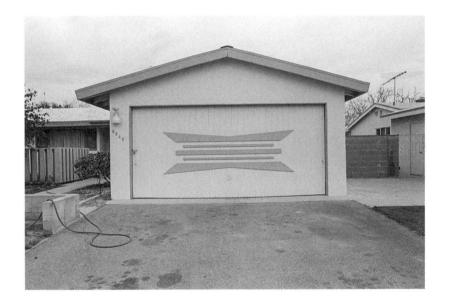

Garages are architectural technologies devised to protect machines. Through the last century the space's original function became redundant; as more and more cars were left outside, garages started becoming polyvalent spaces whose main function was carried out for only a few hours a day. When closed they hide their empty interior behind a giant door, but sometimes, in a quick glimpse, they allow the passerby to see what secrets lay dormant beyond the threshold. The space offers protection from the inside of the home and the outside world. The automatic garage door, with its remote-controlled opener, which only the owner has, is a second layer of security. It is a nuanced form of access. No one could come in from the outside. The noise it makes forewarns of the arrival of mom, dad, husband, or wife, so that the activities that are happening inside without them can be reformulated and made ready for the public.

Following the genealogy from someone tinkering with a car, back pressed against the cold, oily floor, to the creation of the first personal computer, the garage became an inhabitable threshold once it was occupied by the human rather than the machine. The garage without a car lost its prescribed use and became a *deprogrammed* room, a raw residential space that could be easily appropriated for a new set of codes and behaviors that weren't particularly domestic. Garages are big rooms with even

bigger doors; in terms of square meters they are the most valuable in the typical suburban home. So it comes as no surprise that as the other rooms in the household became suffocated by overtly specified functions, the garage was appropriated for the emergence of a do-it-yourself attitude. The garage provided a space for the amateur to evolve, far away from the shackles of professionalism and hidden enough from the familial pressures found in the rest of the home. It seems that those who occupied the garage were always standing against the bureaucratic walls that produced the room, in opposition to but still inside of the Fordist line of production. Depicted across media as a disruptive figure, the garage native is a character of possibility, of change, of a different kind of existence. From the likes of Wozniak and Grohl to Jobs and Cobain they have shown a form of occupation inside the garage that goes against the striated space of the suburb.

The garage remains a garage even without a car inside its walls, yet the space has accumulated manifold meanings and uses since its introduction in the Robie House, so much so that we refer to the garage without specifying a defining activity. The space can be seen as a catalyst for innovation, as a symbol of tech entrepreneurship, as a pleasure zone, and as a site of disruption. In this way, the deprogrammed garage is as much a fact as it is a cultural construction: a reality built from unreality, a blank screen, constantly reconfigured by the fantasies and desires of whoever inhabits the space. The deprogrammed garage, populated by words and images, does not occupy a single position in space and time; rather, it is a palimpsest of situations that reveal a social unconscious that refuses reality.

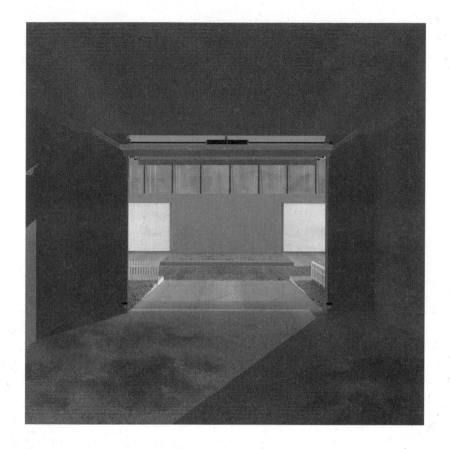

Deprogrammed garage, rendering by Luis Ortega Govela.

(FOLLOWING SPREAD)

Levittown, a burning garage mood board by Luis Ortega Govela.

Through its deprogramming, the garage functioned as a conductor for new thinking, new subjectivities that would forge new identities and actions. You must fight something in order to understand it. The garage became both an "antisocial" space for the lone person to retreat within and a "social space" where one could redesign the traditional hierarchy of a family and business. It can be seen as an architectural typology with its own set of occupational behaviors and aesthetic codes. Unable to be defined as either residential, industrial, leisure, or infrastructure space, the garage put the suburban model in reverse by inserting work back into the home and undermining the FHA's rules of conduct. How punk to hate suburbia, to break past the cul-de-sac, to refuse the organization of work, to reject society's fundamental power mechanism.

### MAN CAVE

In the film *American Beauty*, as the family ignores the garage Lester Burnham, the patriarchal figure played by Kevin Spacey, embraces it, forming an intimate relationship between his identity and the space. The garage functions as an apparatus for retreat, from the refuge of home. The main character is going through a midlife crisis, and he feels suffocated in his house, finding his home a place he can't escape. Reaching an impasse with his suburban life, he dreads the return to his patriarchal role.

For Burnham, the garage presents itself as the only space where, instead of a crisis, a midlife celebration can take place. He can light up, work out, jerk off. Separating himself from his identity as part of a couple and his parental role, he reclaims his lost masculinity. The cinematography emphasizes this by secluding the garage from the rest of the home; the camera focuses most predominately on Spacey's actions within the space, directing the viewer's eye to his weightlifting and close-ups of him lighting joints. The garage appears secluded from the rest of the home, a different entity

from the prescriptions of suburbia and the vent for all its deceptions. Spacey takes control of the garage, finding intimacy without its heterosexual domestic constructs. Finally, alone, he kills his character, going off script to define his new self and in the process characterizing the deprogrammed garage as a primitive space for the macho. As the two come to define each other, the garage is Spacey as much as Spacey is the garage.

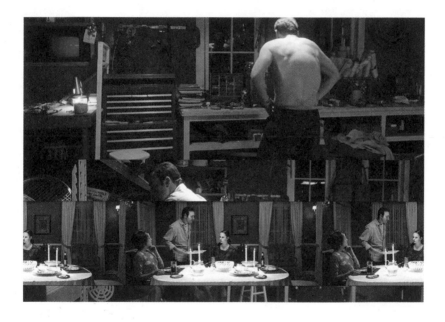

Stills from *American Beauty*. Lester Burnham, played by the now disgraced Kevin Spacey, uses the garage to fulfill his macho fantasies, finding freedom from the overprescribed rooms in the rest of the home like the dining room.

(FOLLOWING SPREAD)

Stills from *American Beauty*. Kevin Spacey working out, reclaiming his lost masculinity in the garage with empty Californian living room. Mood board by Luis Ortega Govela.

In the film the deprogrammed garage functions as the *man cave*, a depiction rooted in a reality that permeates the suburban home. The patriarch's thirst for more space seems unsatisfied by what the modern city already provides him and he goes on to construct and claim the garage for his private use within the housewives' territory of the home. The use of the word *cave*, the primordial refuge, reflects the need to build upon an alternative past rooted in primitivism, the man reclaiming his status as the hunter who returns home after a hard day of work and walks into his cave to satiate his underappreciated labor by drinking a beer with his bros. This romanticized version of a primitive past is constructed by the paranoid mind as an outside, as the anticapitalist answer to neoliberal anxiety.

The man cave is the male sanctuary within the home. It is the space where men can escape the presence and dominion of women. Inhabiting it is in reaction to and acknowledgment of the power of the feminine and its influence on daily life. Within the enclosed creative space of the distinctly male garage, the man acts as builder, constructing model airplanes or a new sense of self, sweating underneath the hood, hammering together like cavemen with their clubs new tools for existence. The characters of the garage are colored by the absence of a father figure. This cycle of abandonment becomes an epigenetic epidemic. The traditional familial structure has ruptured and more households are comprised of blended families or single parents. The reproduction of toxic masculinity is built upon the myth of the "father," and the garage seems to be a place where, regardless of gender, the inhabitants of the home learn the codes of masculinity.

During the 1950s and 1960s, the man cave turned productive by providing an empty landscape for young Cali dudes to envision more primitive forms of transportation. From the surf culture of Venice and Santa Monica to Zephyr skateboards, their new tools protested the car in its need

for fuel and created new tribes with their own methods of movement. Outside of the home and the watching eyes of their mothers, they retooled the garage into a subcultural center. Jeff Ho, who started the Zephyr skate crew, began by designing his surfboards in his garage, which he repurposed and reshaped for his friends. They rode waves, and as Ho began making skateboards, concrete. The ejaculatory expansion of the space, its history of machine and muscle, hitting the pedal to the metal, intermixed with absence. It became their hangout, their den, and while they were far from midlife crises, the boys-club attitude painted the walls of this garage with their fresh testosterone-driven dreams of greatness. Their legacy continues to define a counterculture now taken as a norm.

Skateboarder in midair by Olivia Erlanger.

In the darkness of the garage, it can be hard to separate good secretes from bad. Kevin Spacey plays a sexual predator both on and off screen. This is not a question about sexual preference but one of power, and the need to abuse it. In the hetero construction of suburbia, the image of a man in crisis, one who falls on the wrong path and makes all the wrong decisions, has been misconstrued as a character we must empathize with; no matter how rotten his path becomes he is regarded as the hero. This has become a kind of visual trope, a representation of reality that offers a peculiar kind of reassurance through its repetition. Finally, the world seems to be understanding that these behaviors as much as the garage are slowly becoming souvenirs of the twentieth century, synonymous with the creation of a heteronormative white residential enclave whose dismantlement has long been overdue.

The man cave illustrates the slow demise of the patriarch over the past century, claiming his space in society behind the huge door. The bro who still operates inside the garage's walls is perpetually in a crises of masculinity, holding on to a nostalgic way of being, refusing to get with the program. The garage becomes his last bastion, the place where the macho can find certainty. If we look at the home as the she-nation from which we all hail, when the cis white male occupies the garage as man cave he is holding on to a past in which he was the only one with the privilege to claim space. Juxtapose this with female empowerment and we can begin to understand the performance of masculinity as a role we have all *leaned-in* to play, with or without the phallus. Sexual hierarchies are always at the service of a project of domination that can sustain itself only by dividing, on a continuously renewed basis, those it intends to rule. Phallocratic ideology has claimed many victims, and those who have been abused by it usually live out their victimhood through others, as they often become abusers themselves.

Jodorowsky suggests killing the legacy of your father by painting the soles of your feet with a sun as you walk on the top of the tallest building. But to kill is to perpetuate violence, and violence is a trait of toxic masculinity. Destruction itself can be generative, but how do you escape the legacy of destruction it reinforces? The most subversive means to free oneself of the cyclical nature of this abuse is to become pregnant: pregnant with ideas, possibility, to contain multitudes rather than a singular way of being.

## TEEN LAIR

In the walls of the suburban home boundaries are created around traditional relationships by allocating more square footage to the master bedroom, giving the dutiful son and chaste daughter a reduced amount of space. And while the identities of mother and father remain relatively fixed, their pubescent child is a loose cannon. Suddenly growing body hair, coping with skin breakouts, and attaining sexual maturity, body and identity go into crisis. The garage creates a space for the teenager to fantasize about withdrawal and dropping out. It is a space to be filled with angst, where one can rage against the machine and contest conformity rather than becoming "another casualty of society." With these enveloping crises and without a space to rebel, teenagers would explode the balloon frame, taking down suburbia in their quest for a new familial role.

*Mutter und Vater* represent the barrier between the teenager and mass culture. They remind our teen selves of our limited agency. Transmitting more than just complex data as DNA, parents pass down programmed behaviors that reproduce, among other things, a dominant culture. But times change, economies rise and fall, and the promise of stability becomes increasingly obsolete in the age of super viruses and global crises. The rigidity of norms and pre-established hierarchies are rejected, and the suburban habits that used to dictate teenage existence are constantly rethought.

Perpetually shoplifting identities, teens are authenticity machines, proving who they are by buying into an aesthetic. This is the "hot topic" ideology in which corporate interest controls trending individualism. Teens dress in the drag of their preferred subculture: goth, with piercings and dyed hair, or skater, or basic fuckboi, communicating their dissent via outward signifiers. The desire for authenticity scars their unwrinkled skin and plasters their desktops with screenshots of the aspirational demigods they consume and embody. This consumption of identity is a pattern of behavior symptomatic of suburbia. The home limits the development of divergent identities and the highway that connects it to the city locks the body into a mechanized movement shutting the teen body out of an expressiveness and freedom. Identity becomes not just a lifestyle but a performance of legitimacy, forcing teens to prove the depth of their involvement in each subculture they associate with—you not only are goth, you were born goth. Accordingly, manufacturing authenticity and the idea of a true self becomes the antidote to the disease of prosumption—production by consumers.

The fantasy of withdrawal, of dropping out, is epitomized by how teens push and create space. Protesting their families' private pathologies, they seek out basements, garages, and bedrooms in which to hide and redefine themselves. Youth escape the balloon frame by slipping through its walls, occupying the in-between where the wires and cables that connect them to a digital world allow them a space to manifest their hostility toward the structures that represent the indulgences of the bourgeoisie. This threshold is a delirious reality: teens become the product and creators of what they protest.

The teen lair is a flexible space for teenage dirtbags to experiment with potential identities. Teens engage with a physical as well as a virtual space, using both to redefine the roles prescribed by their families and to designate areas in which they can be themselves. As teens contest hierarchies at

home and school, the same power structures limit them on the web—just corporatized and better disguised. Authenticity of self and experience that the teen user so desperately seeks is fed through one long lit advertisement. The essence of youth is the ability to constantly forge and erect new identities. You must disown or deny your old self to flow out of the balloon frame and into the city, injecting new life into dead space. After the death of one's self comes the creation or reincarnation of another.

Photograph from a. or fifty thousand, an installation by Olivia Erlanger and Luis Ortega Govela done at 88 Pitt St. with Olivia posing as Lynda Benglis with a Badlands Unlimited protest sign.

## GARAGEBAND

All the warnings from the punk rock 101 courses over the years, since my first introduction to the, shall we say, ethics involved with independence and the embracement of your community has proven to be very true. I haven't felt the excitement of listening to as well as creating music along with reading and writing for too many years now. I feel guilty beyond words about these things. For example when we're back stage and the lights go out and the manic roar of the crowds begins, it doesn't affect me the way in which it did for Freddie Mercury, who seemed to love, relish in the love and adoration from the crowd which is something I totally admire and envy. The fact is, I can't fool you, any one of you. It simply isn't fair to you or me. The worst crime I can think of would be to rip people off by faking it and pretending as if I'm having 100% fun. Sometimes I feel as if I should have a punch-in time clock before I walk out on stage. I've tried everything within my power to appreciate it (and I do, God believe me I do, but it's not enough). I appreciate the fact that I and we have affected and entertained a lot of people. I must be one of those narcissists who only appreciate things when they're gone. I'm too sensitive. I need to slightly be numb in order to re-gain enthusiasms I once had as a child.

Kurt Cobain was found on April 8, 1994, in the greenhouse above the detached garage in his Seattle home. Next to his body was a suicide note on a white piece of paper stabbed with a red Bic pen into a flow-erbed. In this room above the garage the smell of teen spirit was fading, replaced with the plastic tape, crime scene chemicals, and the dozens of personal smells coming from the white shirts inspecting his death.

In the early 1990s, with the advent of the internet and e-money, the garage reasserted itself as the prototypical space of the angsty teenager by becoming, once again, the platform for the suburban outcast. It was fertile territory where alternative selves could be cultivated and strengthened in isolation. In the garage subjects rebel against the history that created them and in the process they try to create a new suburban paradise. A space in which to hate suburbia!

Think of bands like Nirvana, which resonated with a generation tired of glam and heavy metal by selling a fresh authenticity in its self-expression. The costume was everyday clothing, flannels with jeans and work boots rather than the sequins and teased hair that characterized the eighties. The sound was purposefully lo-fi, with lyrics that were introspective rather than anthemic; the band couldn't have expected that its songs would be put on yearbook pages or printed across T-shirts. "Stripped down" and bare, Nirvana defined the sound for the angst-filled youth as they sang about the decay and end of American values, Kurt Cobain's voice exuding a kind of desperation, exacting catharsis in struggling teens.

If the band was structured to replace a family, a lead singer could play father while guitarist and drummer could play brothers or sisters. Who knows what role Kurt saw for Courtney Love when they first met; her part in the band Hole could've made her both a frontrunner and a mother. Regardless, the growth of their relationship turned Cobain into a public figure, whose tragedy and pain bled audibly in every song while the disintegration of his personal life, with his newborn child Frances Bean, was painted on the covers of trashy magazines. In the documentation of their first public appearance with Frances, Courtney grins with the baby on her hip while Kurt appears hella stressed on the side. Visibly distressed by the surrounding photographers, he holds an empty baby bottle in one hand and, with the other, reaches for his sunglasses to better hide behind. The images helped popularize Kurt and Courtney as two outcasts, born out of a kind of otherness that they commodified with their music. The Cobains had tried to use the garage to rebel against the normative history that created them, but found

themselves caught reproducing the same idea of family that they had defined themselves against.

Enter the mosh pit of a No Doubt show in the early 1990s. Their sound was new, a blender of genres from punk and ska, to reggae and rock, with a lithe female lead, Gwen Stefani. In their first album Gwen screams: "Trapped in a box of tremendous size, it distorts my vision, it closes my eye, reality gone with a single click," directly referencing the Anaheim garage in which the band would practice and perform for their friends. Yet the band was bound to break out of the garage and onto the world stage. The breakthrough came via disaster, as it was only in the public failure of her relationship with bassist Tony Kanal that they found mainstream success. The band used the destruction of their relationship as inspiration for new songs on their album "Tragic Kingdom," which catapulted them into performing world tours. And the band structure, as familial supplement, came crumbling down, too. The media focused on Gwen, just a girl in the world, the hot blonde; raised up, she cast long shadows over her former lover and band brothers.

Once you see past the punk, the paradox of the figures that hid behind the garage door is outlined. Born under suburbia's pitched roof, they inevitably dwelled inside the structures of patriarchy, at the same time confirming and denying their suburban condition. The inevitability of branding has sketched them as saboteurs, within and against the futurity of the heteronormative family. And yet, try as they might, they always remained within this framework. They projected the stability they so repudiated for the appropriate cultural and financial investment of the world outside, becoming the emblems of the

alternative lifestyle, one that was never as alt as it claimed to be. They were both the product and the designers of the dialectical opposition embedded in the suburban tripartite zoning strategy of industrial, residential, and leisure zones. This fragmentation of the self resulted in a consequent collapse of Nirvana and No Doubt's proposition of band as alternative family structure and reveal the Faustian bargain one has to take when opening a project up to public investment. Record deals, music execs, and an audience twist and repackage the punk identity as a product that can be easily consumed, and people are always left wanting more.

(FOLLOWING SPREAD)

*Faustian Bargain*, mood board by Luis Ortega Govela.

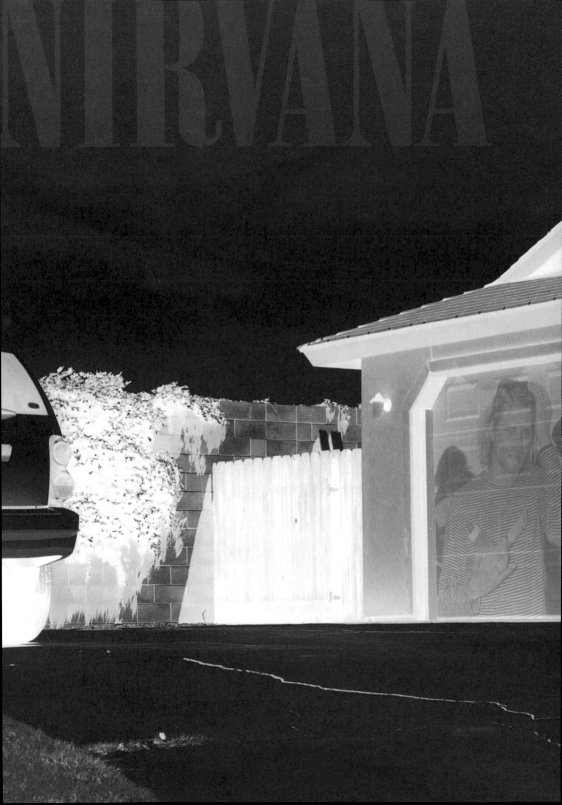

**TABOO**

The garage is the only room perpetually shrouded in darkness, no matter the time of day. It is the Freudian id of the home. The rules of the home, its cleanliness and pre-established order, do not apply here. Without windows, personal obscurities can be explored; dreams of success and demise can manifest.

In different iterations of reality, it has acted as gas chamber and as bondage lair. Take Lux, Kirsten Dunst's character in *The Virgin Suicides*, who dies, cigarette in hand, locked inside the family garage with the station wagon running, asphyxiated by carbon monoxide. Its reality is as dark as its scripted construction; from hiding the Columbine shooter's guns to the television sociopath Dexter's favorite place to cut up a body, it provides shelter for the illicit and hidden desires of its users. For latent psychopaths, its walls are a canvas upon which to paint their bloody desires.

Written in 1973, J. G. Ballard's *Crash* describes the erotic desire of the car crash as a sexuality born of new technology. In the novel, car accidents are the sites of arousal. Rather than feel worry or anxiety over the close proximity to death, the crushing and twisting of the powerful machine around the fragile human body creates an "erotic delirium." The garage then becomes the den for a new sensuality, one fixated on the nonhuman and embedded within the extruded plastic, leather and steel that comprise the automobile. The suburbanite confined by monogamy and the restraints of playing a role develops a sort of schizophrenia, and the garage allows for this double life to take place, for the darkness to be embodied.

Image of Mano Ponderosa on top of a stone carving of a
crucifixion scene by Olivia Erlanger.

The garage perverted by a machinic desire is appropriated for suburban adulteries. Take Salma de Stein, a young woman who was paid to stage a crucifixion in a garage. She and two other dominatrices were sent sterile nails, the specifications on how to build a cross, and a script to read from. Acting out this Texas real estate mogul's fantasy, the three flogged him until he bled and then nailed him up, arms spread wide against their homemade cross. As blood trickled out from his hands and ankles, they read from the script describing his crimes against Rome. In the garage, sexuality and deviance can be explored away from and yet connected to the expectations of filial duty. Outside of the pressures of compulsory heteronormativity programmed into the other rooms of the house, the garage exists as a psychological space within which illicit fantasies can come to life. For crucifixion or murder, the garage is the psychological space within which the compartmentalized can unpack.

**GARAGE SALE**

The word *garage* stems from the french *garer*, meaning "to shelter, protect, or keep under cover." The garage acts as a repository for its inhabitant's anxieties around a past and a future. It is where the real personality of the home lives, offering protection and the covering of narrative-infused objects in translucent plastic or under a cardboard box lid.

In the deprogrammed garage, commodities that had been consumed by the household are reintroduced into the market via their front yards. While the deprogrammed garage functions as the cupboard for hardly used objects, when the garage opens its door to the public to assess value and barter a fair price, the cupboard gets emptied, converting a family's shit into gold.

Collage by Olivia Erlanger. Image of Martha Rosler's *Monumental Garage Sale* and a conceptual heel.

If the mall was the preferred space of the suburban consumer, one in which they could buy into a normalized and prescribed identity, the garage sale allowed for individuality and the reinvention of the self through the acquisition of other people's property. Despite the fact that the objects found there are mass produced, the sheer nature of being stored in the garage injects personality and history with dust and nostalgia. Unlike the estate sale, where the objects being sold are valuable, in the garage one would typically find disused toys, broken appliances, out-of-fashion clothes, and old albums and books.

The hoarder garage speaks to a larger psychological condition brought about by the consumption of goods embedded in capitalism. It is the American distortion of ownership brought to its endpoint as the sickness of harboring possessions. But it is also a refusal by the owners to occupy space for themselves, letting and embedding their objects with more value power than the self. It is a life lived vicariously through commodities.

The garage became a center for the conspicuous consumption of the decayed objects of postindustrial decline—a passive resistance toward production, since consumption became an act of reuse. The garage sale creates new value in the unwanted and the use-value becomes a memory. The fear of forgetting is manifest in the space as it becomes a *Wunderkammer* to keep track of the past. It is where failed marriages are represented by failed possessions. The space can be filled with racks of clothes, still smelling like lost loves, keepsakes from first or last dates, letters never opened. It can become a receptacle for the psychological overflow of the unliving elements of our lives and yet the inert objects come alive with the infusion of memory.

*For Quentin (Medium Rare)*, 2015 sculpture by Olivia Erlanger. The burnt cowboy hat is dedicated to Quentin from William Faulkner's *Sound and the Fury*. Faulkner's story describes the disintegration of Southern gentry, which is mirrored in the destruction of the cowboy hat, a symbol of Americana.

(FOLLOWING SPREAD)

Nic Seago's studio in Highland Park, where images were produced for this book.

*No Doubt*, mood board by Luis Ortega Govela.

## START-UP GARAGE

"Lies, all lies, Peer!"   IBSEN, *PEER GYNT*

The garage is a space that imposes freedom from the consolidation of power imposed by church and state onto the home. The earliest garage is the stable, intrinsically tied to the symbol of the Christian nativity. This first temple was a sacred location next to but separate from the home. It represents the humble origins of Jesus and, through its implied proximity to the home, sharing the plot of land, sanctifies both the hearth and manger as areas where miracles and the divine occur. The garage as a space of transition reflects the waning interest in monotheism and the new religion of the self, of individualism. As the stable became a garage it nestled its way into the home; the shift further confused religion with that of the individual. It became a temple to the self.

For the suburb to exist as a form of currency without losing its sentimental value as a refuge, the garage provided a physical and ideological distance between home and work. At the same time, the heteronormative space of the family could not exist without the garage. The deprogrammed garage existed as a deceitful and powerful image both producing and contesting the domestic idyll of the suburb and became the space where the moment of invention could happen. The garage's walls no longer housed the car but, rather, the entrepreneur, the paradigmatic machine of production of the neoliberal age. Within the start-up garage, electronics replaced automobile production lines. This was the mark of a new generation, which the car aided but was no longer invested in, and where people sought a different kind of mobility, facilitated by the personal devices that plugged into the information highway.

The mobility and freedom inherent in the garage turned it into a causal center of production, one that reintroduced labor into the home. It became

the space where the professional was emancipated. In its cultural represen-
tations it acted as the vehicle for the self-made individual—an individual
who lingered between home and work, private and public, amateur and
professional, who existed within the threshold of entering the market as a
commodity.

It is through the garage that the self-assured entrepreneur makes his
entrance onto the stage of history, quenching his thirst for autonomy by
method-acting his imagined freedom. The self-employed entrepreneur
who uses the garage as an alternative office reflects how the space was
infected with labor from its inception. The apparent disconnect brought
about by the car between work and home is an imagined reality sustained
by the housewife and the introduction of this new technology. The garage
becomes an incubator for the entrepreneurial subject emerging from the
high pressure, success-oriented, individualist America. Once the garage
was dwelled in, occupied, and appropriated by start-up culture, it began to
recycle and fabricate memories and myths that have supported its iconog-
raphy as the space of invention, thereby blurring the reality and image of
the garage.

The deprogrammed garage's tenants use it as a dream box for reinven-
tion, for rebranding their selfhoods. In the delusional search for success
people attach themselves to the myth in order to garner the right atten-
tion, and among this sea of risk is one about Sisters of the Valley, a group
of secular nuns who started growing weed in their garage in Merced, Cali-
fornia. Middle-aged, with large clear aviators, Sister Kate dressed as a nun
as a form of protest during the Occupy Wall Street movement in 2008. She
transformed from "Sister Occupy" into a weed-growing nun a few years
later in an effort to start a grow-op from her small garage. Gradually she
hired more women and clad them in nun's habits.

Sister Kate capitalized on the language of start-up culture, which propagates divergent thinking. Her business was a "new" model offering blessed cannabidiol, or CBD, bathed in the light of full moons. Constructing a brand that offers a new hierarchy, political agenda, and mixing of magical and religious signifiers, she attracted customers by describing her business as a "feminist permaculture movement." Fact or fiction: it doesn't matter as long as these signifiers helped to distinguish the company from its competitors; therefore, it can be argued that her unique business model was based not in her passion, necessarily, but rather in a desire to stand out. Ultimately, the position they've taken is sales driven. From those first marijuana seedlings, she captivated the media with her nun drag and the CBD product. She does interviews with celebrities and capitalizes on her own charm to increase her audience, creating a media machine that exists to generate profits. Sister Kate revises her history according to interest, capitalizing on a narrative that moved her out of homelessness and into a million-dollar industry.

Frank Lloyd Wright, in his own search for clientele, founded Taliesin West, a commune cum architecture studio. The project was run by underpaid architects who believed that their proximity to the Wright legacy would elevate them in their own careers. Wright created a brand based on his system of beliefs. By creating a retreat for people who valued his definition of the American vernacular through his Usonian ideals, he wrote himself into history. A savvy play such as Taliesin helped contextualize Wright's legacy and simultaneously increased the value of his work while widening his pool of clients. Wright understood the power of branding; rather than wait for the slow roll of history to build him a legacy, he manufactured it himself.

Apple, Wright, and Sisters of the Valley share a success rooted in an ethos that attracts people who see themselves as being different from the masses, who hope to defy stereotypes, and who are in search of a sense of belonging. The cult of branding allows for an epicenter around which people can congregate; the small Macintosh computer creates a feeling of fidelity between users, and the nuns' uniform reflects a devotion to their brand construct. Douglas Atkin, in his self-help book *The Culting of Brands*, refers to this as "an establishment of a mythology that leads to long term relationships between a company and its customers." Echoing the HP rebranding strategy, these self-made entrepreneurs strive to create #believers out of their customers. Mythmaking has become as central to sustaining our economy as profit making.

The garage mythology is one that capitalizes on feelings of alienation. Both Sister Kate and Wright created brands that inspired communities to congregate around their products. The brand identity manifests a feeling of actualization as people are able to attach themselves to each founder's movement. Business is not only about inventing something new but also about being able to tell a convincing story that creates a sense of family. In the entrepreneurial pursuit of a techno-enlightened humankind, there is no distinction between nurturing the self and extracting the minerals of value from the core of "the other." They exceed intention; it's about circulation, consumption, reification, profit, competition, and exploitation. But it also presents us with an alternative, with a different certain form of life. In these stories the ethos behind the American Dream is revealed: outsiders who succeed. The painterly depiction of the underdog reaching success found in the media and propaganda is an image that both empowers and absolves guilt.

## PLASTIC GARAGE

The feminine ideal of the second half of the twentieth century is inscribed in Barbie, a plastic, lipless, beige doll. The impossibly thin, Caucasian, blonder-than-blonde Barbie became the obsession of American children, as it represented a beauty ideal that prevailed in postwar culture. Sexy yet neutered, the fashion doll was created by businesswoman Ruth Handler, whose husband, Elliot Handler, cofounded the toy manufacturer Mattel within a Californian garage.

In suburbia all work was women's work. Women were allowed everything and nothing within the home while men had studies, gardens, and garages to retreat to. No space is the mother's alone as children and husband take over every inch. While different levels of agency could be accessed through new technologies that infiltrated the home and body, the housewife was limited in her ability to escape the prison of domesticity. Suburbia itself was built on the backs of women who cooked, cleaned, and cared for both man and child. This exploitation of motherhood and domestic servitude was Freud's only teat. He created a branch of psychoanalysis in which women were blamed for mental illness. Oral, anal, and phallic stages focus on physical proximity of the infant to the mother, yet it is only within the Oedipus complex that the father is held responsible for the stability of a progeny's behavioral patterns. The housewife laid the foundation of stability for the rest of the family unit. The female body has been a site for commerce for millennia, and in the twentieth century it was the housewife's labor that was traded by domestic men against dowries of mortgages and car insurance.

Modeled after the curvaceous adult toy Bild Lilli, which Ruth found while traveling in Europe, there was nothing of the baby doll about Barbie.

Originally Lilli was a gag gift given to German bachelors; she was a miniature molded into the female form, a woman literally objectified for men to carry around. Previously girls had been given paper dolls or toy babies to hold and pretend to care for, enacting a predetermined future. But with Barbie, Handler wanted to give her daughter a doll to playact her dreams and experiment with who she wanted to become, outside of the role of housewife. To Handler, "Barbie always represented that a woman has choices." Her home, the Barbie Dreamhouse—a small box with a suburban facade painted on the outside—was missing some architectural elements: there was no kitchen or washer dryer, so there was no implication that Barbie knew how to cook or to clean, and no implication that she should. But she had *style*. Bitchy heels, pocketbooks, and flair, her fashion reflected a woman who not only left the kitchen, she left suburbia. In this way, Barbie came to represent a liberation from the duties of the traditional housewife. This freedom mimicked the freedom women were sold during WWII as Rosie the Riveter encouraged their integration into the workforce. She, too, was an independent woman.

Within one year of Barbie's debut in 1959, the first oral contraceptive pill was made available. While Barbie created the image of what womanhood, and a woman who has choices, looks like, the pill regulated the hormones of the new woman; Barbie's lack of genitalia, or even an orifice, mirrored the potential absence of pregnancy. Developed and distributed by the thousands, the pill and Barbie together proposed a postwar woman altering her body and giving a sense of opportunity by synthetic means. The introduction of hormone regulation projected a similar sentiment to what Handler hoped Barbie would represent: freedom of choice. Pharmaceutical companies came to control the cycles of American women by selling them the idea that they could have agency over their own bodies. As the doll's form became standardized, the cycle of uterine shedding could now be regulated.

*Mechanized Femininity* by Olivia Erlanger. Layers of Andreas Slominski's "Assholes Garage" and the original Bild Lili doll that inspired the production of Barbie.

The Barbie doll is a representation of not only the postwar woman, but also the posthuman woman, born out of the deprogrammed garage. Biology and plastic have met, creating new fusions and fissures in the concept of femininity and womanhood. A female experience is a plastic experience; the flexibility of the form it takes is now possible in the mixing of bio and synthetic developments, surgeries, and hormone replacement pills.

The production of the Barbie doll itself mimicked the manufacturing of the car that had previously taken up the space of the garage. As Mattel grew out of the garage and into factories, Barbies were born on the assembly line. Body parts, legs, arms, and a torso replete with breasts and mound were pressed and extruded en masse. Pieced and snapped together at the joints, the little woman bits slowly came together in a sterilized manner. The prefabrication of the Barbie doll reflected the advancements made in automobile production. If the car represented liberation for the individual from a fixed location, the pill represented a freedom from the idea of biological womanhood. The birth of Barbie was the birth of a mechanized femininity, which would reproduce a sexuality divorced from childbirth.

The attitudes present in the male-led car culture and startup culture had to be appropriated by women as a kind of drag once they entered the workforce. But the pantsuit came with its own layer of internalized misogyny. If one's self-worth is measured by desirability to men, then it creates a horizontal competition among women. These power women, drinking their testosterone-laced coffee, were also sipping on tools of their own oppression. Fittingly, Barbie's sales have suffered in the twenty-first century as the complications in her representation of the female body have boxed her in. In an effort to empower young girls, more recent dolls are multiethnic and differ in shape and size, creating a landscape of femininity that exudes multiplicity as the embodiment of womanhood but one that

is inherently based in a legacy of objectification that remains held within the confines of small plastic boxes produced on the assembly line.

## DIY GARAGE

Fabio Sargentini, in an act of rebellion, moved his father's gallery, L'Attico, from his renaissance apartment into a Roman garage in 1968. L'Attico provided an exhibition space that allowed for new forms of artworks to exist; installations that were previously constrained by the domestic were freed in scale, and new movements like minimalism, anti-form, and Arte Povera found a new home. The bourgeois interior where the gallery had begun seemed anachronistic in a changing society and art scene. To inaugurate the gallery's garage space Jannis Kounellis brought twelve live horses through the door, and there soon followed Sol Lewitt, with his first Italian exhibition and a parade of performance and ephemeral work that was trying to push the boundaries of art creation.

(FOLLOWING SPREADS)

In 1969, shortly after Rome's Galleria l'Attico moved into a new location in the city, a former garage on Via Beccaria, the Greek artist Jannis Kounellis ushered in twelve horses and tethered them to the walls, helping to inaugurate the space and creating a landmark exhibition for the Arte Povera movement. In turn Fabio Sargenti, the gallerist behind l'Attico, flooded the space with 50,000 liters of water as the last show inside the original garage when the gallery moved to a new location. Mood board by Luis Ortega Govela.

Sargenti's last exhibition in the garage-turned-gallery was a move toward the destruction of the space, a cleansing ritual. Next to this image is documentation from Paradise Garage's final exhibition, in which the LA-based artist Oscar Tuazon demolished the garage structure.

Sargentini was the first art-world establishment figure to pursue the use of leftover industrial space. He came to understand, years before New York artists moved into the Soho lofts and warehouses of the 1970s, that the traditional museum and gallery were inadequate to the cultural production of his time. What emerged from the appropriation of the garage was an open and vast space in which an amateur attitude influenced and informed the art-making within, as artworks began to live in an expanded field of installation and performance. These kinds of works refuse to be contained, not only by the expectations of an exhibition space but by how a market would want to commodify them. L'Attico was a testing ground for the avant-garde to create without the pressure of having to make anything commercially viable.

The sense of repurposing and reusing a space with no financial or commercial help fostered dialogues that eventually fed into a white-cube system. Before becoming absorbed, spaces that existed in the periphery, like L'Attico, were fertile ground on which to define new modes of making, offering new platforms of visibility for the artists. The garage acted as an autonomous zone, a space for a breed of creativity that is an auxiliary of the art market. As exhibitions were reformatted into thought-based experiments, the audience shifted, at first creating pockets of resistance within niche dialogues, but once canonized, becoming part of mass culture.

The resistance that Sargentini presented within his garage is an expression of a do-it-yourself attitude. DIY was first used in reference to home improvement and domestic craft projects that promoted repurposing rather than the purchasing new objects. This ethos encouraged self-reliance as an antidote to traditional consumerist tendencies instead of relying on consumption as a cure-all. The

do-it-yourself movement offered an alternative panacea to the presumption disease and was appropriated by many alt-scenes, from indie and punk to computers, biohackers, and winemakers.

The *garageiste* movement is a punk approach to wine making that started in the overtly saturated and carefully protected wine region of Bordeaux. Garage wine is anti-*terroir*, disregarding history and its context as a way to produce wines for popular market tastes and to redefine how wine is made in stifling regions. Since its inception in France the trend has exploded, reaching the frontier of Napa. Wine-making equipment is expensive, so crushing some grapes in the garage with your hands and feet is way more affordable, but it undoubtedly comes with its criticism by conservative sommeliers. Regardless of the negative view cast on the wines by the nostalgic, these DIY vinos became collectable cult favorites and were hard to find until the financial crash of 2008. Since then this homemade juice, as disruptive as it is chic, can mostly be found in your locally gentrified wine stores in Brooklyn, Hackney, Highland Park, The French Concession, La Roma, Peckham. It's the preferred wine of the locally conscious. Currently the biggest collection of these niche, iconoclastic, fiercely independent and small-scale wines is found in China, alongside most of the West's vinicultural products. Once again this defiance of tradition happened within the garage; this subversion of the rules and regulations that protect how the privileged obtain their money seems to be inscribed behind the giant door.

(FOLLOWING PAGE)

Image of Chris Burden's performance, Trans Fixed, in which he crucified himself onto a car with image of architecture models by Olivia Erlanger.

For the DIY biohacker, work meant to be done on an institutional scale is set up in amateur garage laboratories. The emergence of this movement was founded upon supporting heterogeneous beliefs regarding freedom of information, and in the general commitment to improving the quality of life. In *Biohackers: The Politics of Open Space*, Alessandro Delfanti describes the DIYBio movement in the United States as "a network of amateur biologists established in 2008. Their aim is to provide citizen scientists with cheap and open source tools for biological research which is to be conducted outside the boundaries of scientific institutions." When applied to biology, DIY, or "garage biology," becomes a space away from the corporate interest of pharmaceutical development, where educated and self-taught scientists can splice genes and conduct their own research. These labs are occasionally built within the garage to construct a space outside of the traditional pharmaco system, exploring scientists' curiosity wherever it goes rather than being tied to the financial stream of university- or government-funded research.

Biohackers working outside the boundaries of Big Bio, doing garage biology, struggle against legal and technological expectations to forward an institutional change. This same drive toward the opening up of the architecture of institutions is reflected in the artists who have occupied garage space to stand against the immediate commodification and reproduction of work. New York City's gallery district, Chelsea, best describes this transformation, as old parking garages and warehouses were slowly turned into sterilized behemoth showrooms for million-dollar art. The staggered aspirational ladder upward, from DIY project space to blue chip to gift economy to art fairs like Frieze and Basel, is an inevitable trajectory as the alternative scenes become institutionalized. Plaques on old Silicon Valley garages turn the ordinary spaces into architectural landmarks, while medical advancements made outside of the traditional lab become absorbed and redistributed on a large scale.

Performance at L'Attico with a spiraled garage door by Olivia Erlanger.

(FOLLOWING SPREAD)

Interior Render Garagenwerk, a housing proposal by Luis Ortega Govela. The project is a housing model for suburban plots in Palo Alto, CA, that uses the typology of the garage as a way to readdress suburbia and its nonnuclear family subjects. The project goes against the Eichler or Levittown model of postwar suburbia; even though it copies its repetitiveness, it does not elaborate the home with its symbolic value. It makes the home into an infrastructure, a method of construction in the form of a concrete plinth with a light timber frame attached to it. A shotgun arrangement of automatic doors is used throughout to regulate intimacy and separation of space. The project tackles the contemporary condition of the suburbanite not as the white heteronormative family but as one of multiplicity in identity.

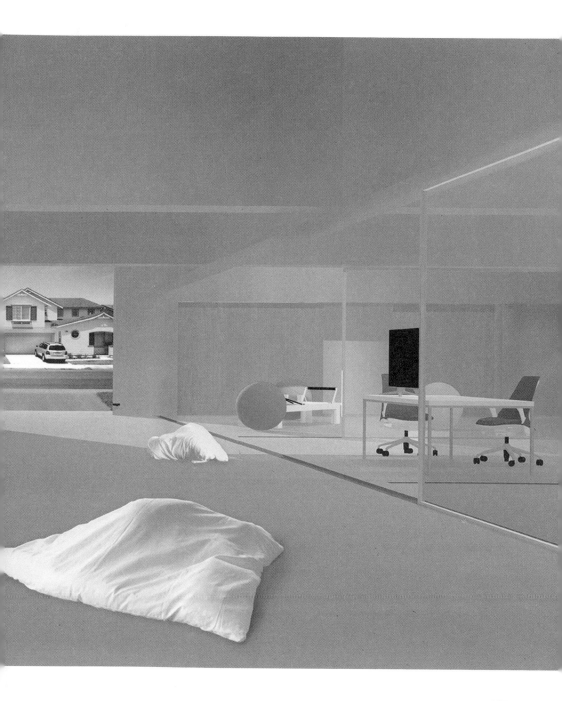

To stand for self-reliance is to stand against the "system," since mainstream culture promotes consumption as not only easy and cheap but right. But resistance is key to innovation. This attitude was illustrated in Sargentini's totalizing piece at L'Attico, in which he flooded the space of the garage with 50,000 liters of water, the ultimate séance against appropriation by a market. Rather than allow his space to become another victim of commodification and gentrification, Sargentini murdered his space. Even if this act of defiance was just a gesture, as the artists he worked with inevitably became canonized, the attempt itself was a form of dissent. After death comes reincarnation. To remain in a state of transition, a state of becoming, this is the ultimate form of protest. Locations like the DIY lab, or garage gallery, are spaces that are constantly open to revision, defying legislature and identities that define bodies within a nostalgic framework. We are no longer performing opposition, we are embodying; no longer projecting, but constructing. Western ego is oriented toward total alienation and disconnection; as such, radical empathy and inclusion are the tools through which we can break with the cultures of consumption. If only to make them stronger.

# GARAGE **CONSPIRACY**

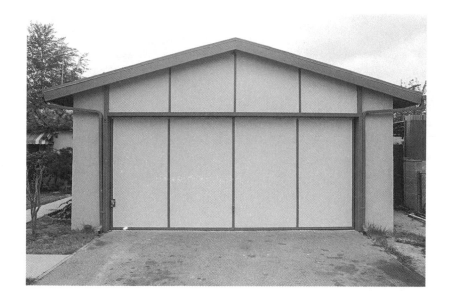

Engulfed by the garage we move in a suburban frame of ownership and its cult of authority. This book posits Frank Lloyd Wright as the owner of the garage, but to what degree is this a fact and at what moment does it become the fiction the architect so wanted us to believe? Once something is owned it seems that it is only the owner who can speak about it, control it, sketch out its narrative and in turn be owned by it. A stage gives you the ability to construct a history, yet this comes with an acknowledgment that property is theft. The Prairie style was a project of rejection and reinvention. By reinventing the home, Wright was reinventing himself, and by reinventing himself, he was rejecting his past. The quickest way to reach reinvention is by rejection: rejecting history, rejecting a tradition that drags us down. He wanted to throw away the shackles of nostalgia; he wanted the previous generation's desires and habits rethought. It was an abandonment of a previous life, tied to his own personal history, almost as if trying to piece back together by each recomposition of his Froebel blocks the trauma of his father's absence, edifying a new foundation, and with it a new beginning. Frank's process was clearly one of antagonism, going against the norm to try and create a new normal. This outdated but persistent myth of the solitary male genius is crumbling, and with it the garage will also fall.

Today, the global system of immaterial labor is overlaid on the existing physical world, absorbing a large portion of the city and eliminating spaces to be punk, as the concept of "the individual" has succumbed to its own commodification. This reached a symbolic point in 2007 with the release of the first iPhone coinciding with the revelation of the scale of the subprime bubble. It permits us to posit smart devices in relation to the crisis of housing, and to appreciate the fact the internet has, at this point, become an essential infrastructure for inhabitation. The foreclosure crisis of 2008 and subsequent market crash revealed the home in its process of abstraction as an object of financial speculation, a revelation that has only accelerated its value as image. The home had become a signifier of status reflecting the architecture of one's personal finances. From four-door garages and endless kitchen renovations, the suburban home became the site of conspicuous consumption. The suburban middle class it produced was propped up by developers as an instrument of financial gain calming insecurities created by the instability of American capitalism.

Now the home appears online, virtually digested through the screen but also as a reference for physical space. Platforms created around the home have rebranded it as smart, as shareable, as a commodity that can be fragmented and used for profit. These spatialize specific relationships and social interactions. If the suburban model, with its architectural technologies, produced the subject it was meant to shelter, like the stay-at-home mom, the white-collar dad, the defenseless child, and the savvy entrepreneur, what is the subject being modeled in the new image of the home?

The garage has been posited as the space where the subject seemingly regains control of where he is going, where the collectivity of the family

is refused. Steve Jobs never acknowledged his daughter and ultimately never gave Steve Wozniak his due. Gwen Stefani separated herself from Tony Kanal to pursue a solo career. Cobain committed suicide on top of his garage, a few years after marrying Courtney Love and having Frances Bean. Frank Lloyd Wright was a serial cheater who also ran away from his parental role. All of these cases are symptoms of a broader political disease in which egoism is king and we are all pushed toward a lonely struggle for survival.

The garage was a technology that displaced the home and its subjects. It provided a space in which not to belong, and in which to question futurity by revealing the tensions between reality and image. Now domesticity is being reformatted once again through technologies that detach the home from the house. Facetime, Airbnb, WhatsApp, Uber, and Amazon are all platforms that replicate some of the home's qualities but that ultimately make the home an entity autonomous from its architectural reality. Through these networks we are offered the virtual and physical ability to inhabit the space of the *other*. It is a seemingly unmediated access to space, but ultimately we choose the similar, the known; we stay inside our bubbles. These platforms operate by bringing the intimate space of the home into the public. Home is made available everywhere, by employing the mechanisms of digital free-market capitalism. Regulated through terms and conditions, the platforms control and surveil how you operate, access, and use space, creating a new architecture of divisions, of fragmentations, of reductions, of prohibitions.

In 1967, the first steps toward what we now refer to as the internet were described by J. C. R. Licklider when he proposed a two-way communication and knowledge network, referring to it as the "Galactic Network." Initially the internet was seemingly gravitationless, a cosmos,

nebulously sci-fi, but now our shared reality of the invisible network is most frequently described via metaphors grounded in the physical. It is an organism, an open architecture, a highway, or a collection of bubbles. The arrival of the internet heralded a new ecosystem, full stop. This concept has evolved to encompass a complex set of virtual environments. As digital agents, we go online and exist within a virtual ecology of bubbles, clouds, mountains of information, streams of content, grids, and suburban webs. This communication system functions within networks of differing environments, all transferring information. As we call upon the power of the web with our queries, it passes our data along, whether it be simple keystrokes or more complex questions halting us in its suburban-like sprawl. The immaterial knowledge and communication passed along the internet is made physical in the hidden grids of cables and wires spanning the globe that connect the dematerialized space, weaving it into both productive work environments and the domestic.

Grids as both an image and physical system were explored by Superstudio and Archizoom, the Italian architecture and design collective. Superstudio used the grid to reflect upon the dispersion of objects and the dissolution of space. In *Continuous Monument* (1969) they proposed "a terrestrial parallel and a crystalline grid that circulates the entire globe." Their proposal for a Utopian system that totalized space and objects debuted concurrently with the dialogues around the early internet. Almost a decade later, in *Delirious New York*, Koolhaas echoed this, writing that "the grid is, above all, a conceptual speculation. ... In its indifference to topography, to what exists, it claims the superiority of the mental construction over reality." The grid has not been replaced and has remained a strong conceptual way of thinking about the internet of things. The tech world in its never-ending pursuit of innovation keeps

rebranding commodities as "smart." From toasters to AI personal assistants these offer a totalizing system of control and surveillance.

The automobile has offered us mobility and invigorated exploration as much as it has resulted in exploitation and environmental ruin. The new frontier is vehicles with smart technologies that support automation. If programmed right, the car has grown smarter, cleaner; it inevitably integrates systems of surveillance for "security." It becomes the seat of the Panopticon, a mobile nexus for state control. In the proposed future, complete with integrated grid, the driver shifts to user, further locking the passenger into a state of blissful inactivity, constantly surveilled and documented. Pinging up our location, our blue dot on the map becomes the beacon of the disembodied. Are we disempowered, or is this freedom actualized? Never having to know where we are going, we displace our agency, our personalized algorithm soothing our lack of destination. Mass-manufactured and going nowhere, we charge forward.

The garage is already a vestigial space, an addendum, a ruin from a different era. The same way humans' homes were fixed in one location, so too did the machinepet of the family deserve a house of its own. With a subscription, cars may not need to be placed within a garage. Like Uber, Lyft, or any of the million other driving services, a car can roll up toward your location and depart after dropping you off. Who needs the hassle of paying for the additional square footage? The car is removed from its stable, and rather than being put out to pasture it will zoom toward its new family-less pen.

The grid promises safety. To function, self-driving cars will act like 360-degree cameras, creating a holistic surveillance system, where every street and sidewalk will be transmitting not only user data but images to

the government. This kind of automation brings optimism as much as it reflects our paranoia. As the physical act of driving is erased, terrorists use the car as a weapon, wounding many as their agency allows them to drive out across public spaces. The paranoid may be thinking of Stanley Kubrick's *2001: A Space Odyssey*'s villainous computer program HAL, which misleads and murders crew members, while, to the optimist, automation and systems like the integrated grid can save us from these soft-target acts of terrorism and bring comfort and ease to our lives.

Just as the grid and the Nonstop City began with the promise of freedom and ease, the descriptions of the internet as an ocean of access to surf or float through information are deceptive. Grids are neutral, the internet isn't; it is a highly regulated fractured spiral. Different systems limit our ability to move through it, filtering content, building frameworks, creating boundaries around each person and his IP address. As the space of the internet has increased, with billions of websites and tens of millions of search queries a day, automated algorithms organize this data, structuring similar items together into clusters and bubbles.

This was not always the case. There was a revival of cyberutopianism with the Arab Spring and the Occupy movement in which hacker movements like Anonymous and Wikileaks became politicized and mainstream. Images began to circulate of public spaces taken over by the 1 percent. It was a revolution organized digitally with the rise of social media; it was seen as a breaking of class divisions, geographical differences, and power; it was meant to be a new dawn of transparency and collaboration. But the Twitter revolution came hand in hand with a rise in internet surveillance. Occupiers had to learn how to avoid having their communications tapped into by the state. Snowden called Poitras and confirmed the level of transgression the state had been using to

listen in, and hope seemed to be mitigated by hardcore sanctions. Instead, what has emerged are alliances between like-minded people. Just as the suburbs promised a kind of Utopia founded upon the freedom to choose how to live as it allowed a workforce to move away from the confines of city living and create new spaces for their families and communities, so was the internet viewed.

The suburb is the most appropriate analog as we experience a suburbanization of the mind via our engagement with the internet. We live in digital neighborhoods that act as mirrored halls of similar content that reflect our user preferences and online histories, showing virtual communities of like-minded people with similar jobs inhabiting similar socioeconomic strata. These landscapes that exist within this biome have been described as smooth bubbles. In fact these are full of friction, rupturing and invading the meniscus and resulting in spiky nests of protection. Pointy urchin-like containers keep people within limited forms of consciousness. The internet is going through its suburban phase of white flight, homogenizing itself for user experience. Rather than confront opposition we use the virtual suburban neighborhood to remain safe within what we know, what is similar, seeing search results and targeted advertising that project back to us what is just like "me." The black mirror of the empty screens reflects our self back to us.

The walls of the digital annex override the existing architecture of the city; the technologies developed within it replicate its structure. The garage has functioned as the space for the destruction of reality, for looking beyond the immediate context, for contesting normativity and habit. Since its appropriation by the market and start-up culture, the garage, the space where man and machine meet, has become an ideology that has transformed the city into a series of garages whose physicality has

rematerialized as an image that continues to operate as an empty promise of contestation, the archetypal typology for the most neoliberal forms of lives.

The cluster and cul-de-sac of the internet have created a virtual neighborhood watch and redlining. The internet gives us carte blanche to stalk and perve at the lives and social lives of other users. This platform allows us to indulge in social exposition by the method of the news feed and, crucially, it acts as a social opiate where we can keep up appearances with a greater efficiency than ever before to an audience that we perceive as always being there. Within this suburban-like existence, empathy and generosity are received only by insiders among the individuated communities of digital space.

The collective found online forever expands while differentiating within its boundaries. The deprogrammed garage acts a safety valve for the pressure that builds inside this nucleus; it becomes a space to hack into and out of the suburban grid system. It had a power to subvert the rules and regulations of suburbia, even if it was only for short moment; the activities that took place in the garage changed and molded the residential zone for new uses and identities to emerge. It shifted the constraints from which its occupier had come.

The algorithmic confinement of the digital suburb makes it impossible to escape the cul-de-sac. Learning from the garage, the digital occupant can apply the strategies found within to distort reality and repurpose online platforms for divergent uses to escape the confines of prescribed behaviors. The other's identity is already built and accessible to be hacked, to be misused, to be dismantled and constructed upon. It functions as a conductor for new thinking, new subjectivities, and action. In

the suburbs the chance encounter was minimized, but there are still occurrences, collisions, and juxtapositions found within search engines and their prescribed algorithms. The most powerful thing that the internet still does today if used inappropriately is that it can constitute new audiences, to form alliances or collisions across boundaries, bubbles bursting bubbles, refusing to appeal to a demographic.

The garage tells a compelling story of subjectivity and technology, translated time and time again by the different functions it has served and housed. The primal scream heard from the garage is muffled by the different media, figures, and stories that appropriate the space as they see fit. It gives a foundational beginning to identities previously outside of the market, the purpose of which has to be constantly questioned. Is it just self-aggrandizing, narcissistic appropriation? Or is it a tool toward empowerment and the creation of something new? In the garage, just as objects get stored and repurposed, so too do the narratives that begin and end within its walls, allowing for people to attach themselves to attitudes previously scripted in the space and its appropriation toward similar end results. The garage mythology is one of endless recombination of images. It operates as a hard drive that keeps expanding; our databases grow infinitely, and it is no longer about originality but rather about the superimposition of different images onto each other. The garage has amassed a large collection of images and stories, which begin to act as mood boards, references that when put next to each other begin to construct. It is not appropriation, plagiarism, or copyright infringement, but it is about a recycling of identity that displaces history.

The genealogy of the garage that has been presented describes an occupational dichotomy. It is both a room for withdrawal and a space for

Roof plan of Garagenwerk, speculative housing proposal for Silicon Valley suburbs. It is within this tendency to use space in less codified and ductile forms that the project's urban strategy sits. The project in its block form strives to surpass the old conflict between work, life, and leisure. Just as the garage has pointed out throughout its history that the distinction between residential, industrial, and leisure spaces cannot be zoned, it actively contests the outdated planning logic of zoning carried out by municipalities. Thus the project rethinks the home as a way to rethink suburbia.

Ground floor plan of Garagenwerk. As a way to contest this lack of codification of the space, the project takes the suburban home and its residential garage as spaces whose purpose is not simply to provide habitat to represent the individual, but rather as true performative devices that tend to produce the subject they claim to shelter. The mom, the dad, the teenager, the child, and the entrepreneur are the result of these architectural technologies of subjectivation. In the case of the nuclear family home we are presented with a hierarchical system with its allocation of square meters through architectural devices like master bedrooms, living rooms, back gardens, and garages. These spatialize specific relationships and social interactions. The project, in opposition to this, provides a modular system based on the parking lot grid (2.4 × 2.4 m), which defines every single space that can be occupied (to sleep, work, or bathe) on the first floor of the typology. The project does not distinguish between activities or occupants by homogenizing the space allocated for all domestic activities to the same square footage. It also allows for different inhabitation patterns to emerge by allowing the presence of unprogrammed and generic space.

coming out, a stage where intimacy is either reclaimed or made public. The room is emblematic of a postmodern condition of operating within and against the neoliberal system. Inside the garage political stances are boiled down to the banalities of everyday life. On the one hand, withdrawing creates opposition, a constant war against the context that surrounds, an antagonism toward the public and the reality at hand; it offers an escape that creates a perpetual race for difference and subversion. Yet the privileged option to disappear, to hide within a reality that is ready to swallow whoever stands within it, is reverted in the search for mass. The image of unruly kids, free spirits who live dangerously, carries the power to contest. The achievement here is how people like Frank Lloyd Wright, Steve Jobs, and Gwen Stefani knew how to transform themselves into events, surrounded by enough media and means of discharge that they were able to individualize in a way counter to their societal preconditions. The antagonism inherent in the construction of the self has come to be regarded as nonconforming, but the approach is one we regard as hardcore realist. These cases are attempts at disempowering the white middle class and its suburbia, the dominant power, but ultimately they seem to reinforce it by glorifying the self and forgetting the collective.

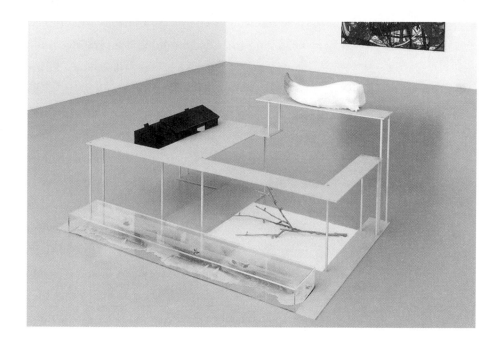

Sculpture, *Floating Loop Strike Back Option*, by Olivia Erlanger. The sculpture is composed of smaller works that point back to the larger "hyper object" of the global financial crisis. The works reside within a system or small architecture that reflect their dispersed but connected relationship. The puzzle house was modeled after a Chinese toy that was popular during the abandonment of cities like Dantu.

(FOLLOWING SPREAD)

Installation documentation of, a. or fifty thousand at 88 Pitt Street by Luis Ortega Govela and Olivia Erlanger.

Leonard, Angus Wall, Sarina Roma, and our queer crew collaborators, Tyler Finney, Sam Kenswil, and Nic Seago.

The biggest kiss of all goes to my friends, who inspire me endlessly, and to the incredible garage-preneuers who opened their automatic doors to us along the way. And, finally, thank you Luis for your friendship; it is the soul of our collaboration.

## OLIVIA

This book is for my mom who, when I was scared of garages as a kid, held me tight and explained to me what the space was. To all my family who constantly have helped me think about what home means and have supported the opening of my garage doors. To my twin brother, Max, whose presence in my life means that home is a concept I travel with; thank you for your support and love in every single way. To my dad who would always tell me an entrepreneurial story before going to bed about how I had to become my own business owner and have a wife and kids; listening to that every night as my predestined future freaked me out, and I have contested it ever since and at the same time materialized it in my own way.

Thank you Pier Vittorio Aureli and Maria Guidici with whom I developed this thesis in its original format at the Architectural Association in 2014 and who quickly understood the queer impetus behind it. To Octave Perrault who made the connection between Olivia and me happen and for helping us decide to write an article together that became this book. Olivia, I'm thankful for your fierceness, and for cold-calling Roger Conover who ended up being an essential piece in the making of this puzzle. To everyone from the MIT Press team: Michael Sims for understanding that sometimes the silent H in Spanish makes its appearance in our writing and Victoria

Hindley for holding our hands throughout intellectual property and image rights debacles. To all the artists who understood the nature of this project and agreed to give us image rights. To John Divola, Bill Owens, Pentti Monkkonen, Andreas Slominski, and Stephan Sastrawidjaja. To Nic Seago for always having a garage ready for me to occupy. To Manijeh Verghese and Brett Steele for providing a stage on which to present the book. To Edwin Heathcoate, thanks for the phone call and your garage picture. And to my friends, without whose support this book wouldn't have happened. To Valeria Aleman, Tom Leahy, Alessandro Bava, Fabrizio Ballabio, John Palmesino, Robert Storey, Eleanor Hill, Angus Wall, Aubrey Plaza, Julia Wagner, Mavi Staiano, Margaret Crow, Isaac J. Lock, Sarina Roma, and Olivia, thank you for distorting reality with me!

LUIS